THE KEY TO ART

THE KEY TO RENAISSANCE ART

A Bateman/Search Press Pocket Guide

José Fernández Arenas
Professor of Art History

Search Press, Tunbridge Wells, England
in association with
David Bateman, Auckland, New Zealand

The publisher wishes to thank Peter D. D'Angio, Department of Art History,
St. Olaf College, for his assistance in the preparation of this book.

First published in Great Britain 1990
Search Press Limited
Wellwood, North Farm Road
Tunbridge Wells, Kent, TN2 3DR

Reprinted 1993

In association with David Bateman Ltd.
32–34 View Road, Glenfield, Auckland, New Zealand

Copyright © 1988 Editorial Planeta, Spain

Copyright © 1990 English language, David Bateman Ltd.

Distributed in the USA by
Worldwide Media Service, Inc.,
30 Montgomery Street, Jersey City,
New Jersey 07302

ISBN 0 85532 666 2

A David Bateman Book

Printed by Colorcraft, Hong Kong

INTRODUCTION

Florence, Italy, gave birth to the Renaissance. The city was the capital of Tuscany, which was one of the most flourishing republics on the Italian peninsula. Florence became Europe's most important cultural and artistic centre during the 15th century. The Renaissance movement originated in Florence because of the particular economic and cultural conditions that existed there. Wealth from trade and manufacturing led to the establishment of a middle class (or bourgeoisie) that valued intellectual and artistic pursuits and paid for the creation of some of the most important works of art of the Renaissance.

The term *Renaissance* applies to Italian art and architecture of the 15th and early 16th centuries and their later versions in other European countries. The word is French and means "rebirth." The Renaissance was an intellectual movement that started in the Italian city of Florence in the early 15th century. It gradually spread to other European countries during the 15th century.

The term *quattrocento*, the Italian word for "four hundred," refers to developments in Italy during the 1400s—the 15th century. *Cinquecento*, or "five hundred," refers to the High Renaissance in Italy of the early 1500s—the 16th century—as well as to the later style of Mannerism and to the Renaissance outside of Italy.

The Renaissance is made up of a complex set of cultural, political, and linguistic ideas that sprang from an intellectual movement known as

MAP OF THE RENAISSANCE

1. Florence
2. Rome
3. Padua
4. Venice
5. Genoa
6. Naples
7. Milan
8. Nuremberg
9. Paris
10. Ghent
11. London
12. Valencia
13. Barcelona
14. Zaragoza
15. Burgos
16. Salamanca
17. Seville

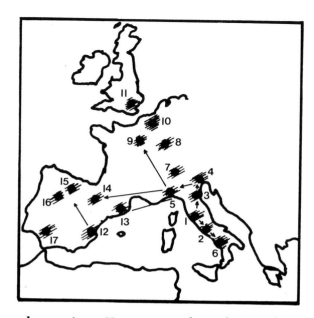

humanism. Humanists admired everything related to ancient Greece and Rome, or **antiquity**. They collected objects from the past, treated them as works of art, and used them as models for artists to imitate. Each piece was thought of as a relic of a sacred time.

The 14th-century priest and writer Petrarch (1304-78) was inspired by the ruins of the buildings of ancient Rome. He saw the Roman age as a period of light and splendour and the Middle Ages that followed as a time of darkness and gloom. Petrarch proposed a return to classical writings to search for truth. In the writings of Roman authors Cicero and Plutarch on the lives of famous Roman citizens, Petrarch found models on which he believed the people of Florence could base their lives.

Other humanist thinkers and artists followed Petrarch's theory, and his ideas spread from literature to painting and the other arts and finally to the sciences. This led to the concept of a revival, or rebirth, of antiquity.

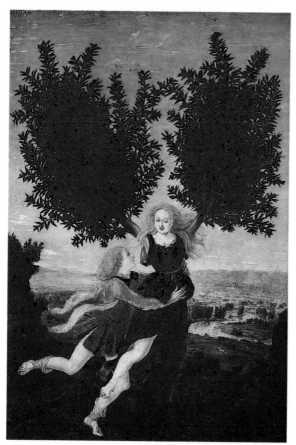

The revival of antiquity had a great influence on artists during the Renaissance. Artists drew on themes from classical literature, sculpture, architecture, and decorative objects. This creative activity gave artists a new social status. During the Middle Ages, artists had been thought of as craftspeople who did little more than give form to ideas from God. With the interest in antiquity and humanism during the Renaissance, the artists' ideas also became important. The interest in antiquity and humanism also created a new group of patrons, who bought art and helped increase both the commercial and artistic value of antique objects.

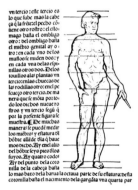

enlos hôbres q son enanos o môstruofos o mal entallados. ¶ Has de saber q el rostro del bôbre se forma sobre vn qdrado pudo en tres tercios y guales. Del primero se comiença te. Del segûdo la nariz. Del tercero la boca y la barua: segû q enla presente figura se muestra. Enel primero côsiste la sabidu ria:enel segûdo la bermosura: enel tercero la bôdad. ¶ Lo cesq los estatuarios y esculptores de egypto eran tan diestros en las medidas de vn cuerpo bumano que estâdo en diuersos lugares y de diuersas piedras formauâ vna estatua por sus miêbros z ten comunicar

DIEGO DE SAGREDO. Proportions of the human body. *Roman Measurements.* 1526. Toledo, Spain.

The most important of a small number of Spanish treatises written about architecture is Sagredo's book *Roman Measurements.* Sagredo's drawings illustrate his theory about the proportions of the human body.

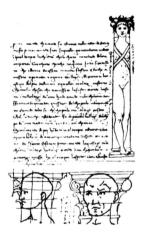

vn tercio : este tercio es lo que sube mas la cabeça q la frêtecl pecho côtiene otro rostro: el estomago basta el ombligo otro : del ombligo basta el miêbro genital ay o tro : en cada vno de los muslos se miden dos : y en cada vna delas espinillas otros dos. Delos touillos alas plantas vn tercio:enlas chuecas de las rodillas otro:enel pescuego otro tercio. De manera que le môta por todo los ochos nueue ro stros y vn tercio segû q por la presente figura se muestra. ¶ De muchas maneras se puede medir los miêbros y estatura del bôbre allêde sia q bauemos dicho. Ay enel alto del bôbre seys pies dlos suyos. Ay quatro codos Ay del punto dela coronilla de la cabeça basta lo mas baxo dela barua la octaua parte de su estatura:desta coronilla basta el nacimiento dela gargâta vna quarta par

gula
Cordon
Corona
Rudon
talon

Theory and Technique

The Renaissance is one of the most important intellectual and artistic movements of Western history and has greatly influenced many artistic styles in the centuries that have followed.

The artworks of the Renaissance were not exact replicas of the models of antiquity. First of all, Renaissance artists did not know everything about the classical world. In addition, Christianity had had an effect on Western civilization that made a complete return to classical culture impossible. But the Renaissance established a cultural world and ways of thinking and living that were inspired by antiquity. The revival of

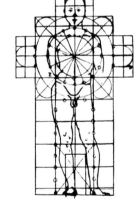

FRANCESCO DI GIORGIO MARTINI. Column, capital, and basilica ground plan. Study of proportions. National Library, Florence, Italy.

Renaissance theoreticians of architecture rediscovered the classical idea that the column resembles the human body in the proportions of its height and width, especially in the capital, or head, of the column. Martini related Vitruvius's theory that the design of religious buildings could be based on human proportions.

antiquity was expressed in different and unique ways in literature, philosophy, politics, art, painting, sculpture, and architecture.

Paintings from antiquity had not survived into the 15th century and were only known through the writings of the Roman author Pliny. However, the fanciful decorations found in the Roman emperor Nero's palace inspired painters to imitate antique forms and themes.

For Renaissance sculptors and architects, there were many antique statues, buildings, and monuments that could be used as models. The Florentine sculptor Donatello was called "the emulator and great imitator of antiquity." In architecture, Filippo Brunelleschi rediscovered antique methods of building that had not been used during the Middle Ages.

The Renaissance was a cultural revival that assimilated ancient and pagan ideas into the Christian world. In Renaissance art, mythological themes from antiquity coexisted with themes drawn from Christianity. Intellectuals tried to bring together teachings from mythology and the Jewish mystics with Christian biblical and religious doctrines of the Middle Ages.

During the Renaissance, humanity became the centre of all things. The Renaissance represented the strongest attempt by artists to interpret the world according to a human scale, surpassing even antiquity in this effort. Renaissance thinkers believed that all of creation centred on and reflected humanity, and that nature could be subjected to human will. Art was a means of human domination in which appearances could be captured, surveyed, and represented according to human rules and proportions.

A new visual language was necessary to record the shift from a medieval world view, which was

VITRUVIUS. Orders of architecture and of capitals. *De Architectura*. Engravings from a Renaissance edition. Vitruvius's theory and the engravings that illustrated many editions of his book were very important for the spread of classical architectural ideas during the Renaissance.

DONATO BRAMANTE. Church of Santa Maria presso San Satiro. Begun 1481. Milan, Italy.
Bramante was in the service of the Sforza family, a prominent merchant family of Milan. In designing Santa Maria presso San Satiro, Bramante responded to an earlier architecture in the city, particularly the church of San Lorenzo. As in San Lorenzo, Bramante used a centralized ground plan for the **sacristy** of his church. The sacristy was designed in the form of a cross that had four arms of equal length and a dome over the crossing. Bramante used decorations that were both traditional and original. They cover the walls and dome, yet do not obscure the architecture.

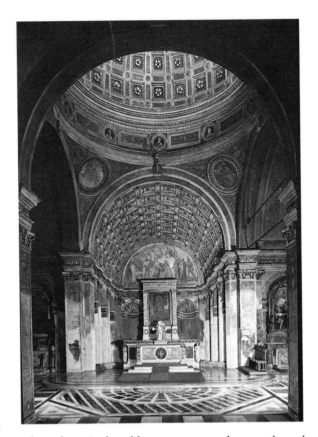

based on God and heaven, to one that was based on nature. The gold backgrounds used in medieval paintings were replaced during the Renaissance by backgrounds that represented the real, three-dimensional world. In architecture, the medieval emphasis on vertical buildings that pointed toward God was replaced by an emphasis on buildings that were horizontal and hugged the ground. Sculptors in the Middle Ages had made statues of the saints. During the Renaissance, sculptors celebrated the human form.

The Renaissance idea of beauty was based on the exploration of nature and its rules. The architect and writer Alberti criticized artists who did not make nature their model. According to

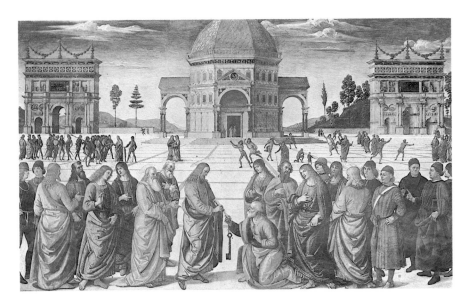

humanist thinking, humankind was central to all nature and was its most perfect creation.

The proportions of the human body determined the correct way to represent the human figure for Renaissance painters and sculptors. Originally, one set of proportions, which used the length of 10 heads to form the length of the body, was put forth. Later, artists and writers introduced variations that reduced or expanded the number of heads used to measure the length of the body.

Physiognomy, the study of the features of the face and the qualities they express, was used by artists to give the people in their works idealistic qualities. Physiognomy was used to express a figure's character, attitude toward life, and positive qualities such as honour and virtue. It was a form of flattery.

The movement of the human body also interested Renaissance artists, especially after the middle of the 15th century. Alberti implied that the soul was the source of movement and stated

PIETRO VANNUCCI, IL PERUGINO. *Christ Delivering the Keys to Saint Peter*. **1481. Sistine Chapel, The Vatican.** At the end of the 15th century, Il Perugino and a group of Florentine and Umbrian artists worked on the decorations of the Sistine Chapel. Il Perugino painted *Christ Delivering the Keys to Saint Peter*, using a spacious, open composition. The individual parts of the fresco—the figures, the buildings, and the background—are perfectly balanced and are arranged according to a carefully planned system of perspective. Il Perugino used light colours and tones to heighten the impression that each figure is real.

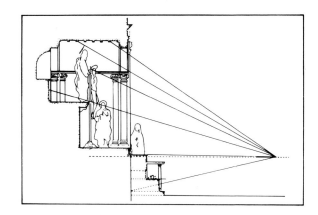

TOMASSO DI GIOVANNI MASACCIO. *The Trinity.* **c. 1425. Church of Santa Maria Novella, Florence, Italy. Diagram showing its perspectival construction.**

The diagram of Masaccio's fresco of the Trinity illustrates the rules of artificial perspective, which represents objects as they look from a single viewing point. When the perspective is done correctly, the surface supporting the painting should seem invisible. To achieve this, the artist must calculate the distances between objects in the painting and their proportions in relation to a single point—the eye of the painter or person looking at the fresco.

that the movement of the body was the language of the soul. Because of this belief, dancing was highly praised during the Renaissance, and from the middle of the 15th century, artists often portrayed figures dancing, as if this were the body's natural state.

Artists also painted plant life and studied nature in an attempt to understand and capture reality. Landscape painting was an important part of Renaissance art. Two types of landscape painting existed. The symbolic landscape, depicting paradise or the ideal garden, was used in both secular and religious scenes. The second type, the real or topographical landscape, was popular in the 14th century in French, Siennese, and Flemish painting. In the 15th century, the topographical landscape developed into the courtly garden, the setting for scenes of court life. Representations of the courtly garden were done as paintings, mosaics, and relief sculptures.

The depiction of the three-dimensional world on a flat surface was thought of as a geometrical and optical problem that could be solved rationally and logically. Space in Renaissance paintings, in contrast to space in medieval art, was realistic in appearance. Brunelleschi has been

credited with the invention of scientific or artificial perspective. He increased and decreased the sizes of the figures in his paintings according to their locations in space. Alberti also applied the rules of artificial perspective to paintings, and he used them to create harmony within buildings.

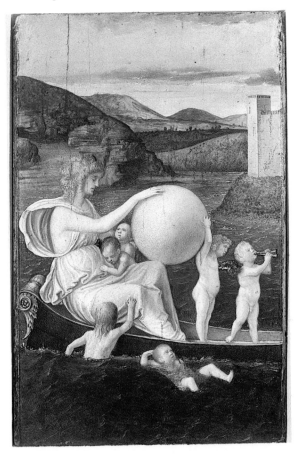

GIOVANNI BELLINI.
Inconstant Fortune. **1490. Galleria dell'Accademia, Venice, Italy.**
The use of perspective allowed objects to be seen as through the frame of an imaginary window. Renaissance paintings often included symbolic figures and allegories in which hidden meanings refer to literary and poetic themes. Here, Fortune, holding a globe, sails in a fragile boat and is surrounded by children. The boat could capsize at any moment, even though the water looks calm. Bellini has painted an allegory of the fickle nature of Fortune. The bleak landscape in the back of the figures represents the harshness of life.

Leonardo da Vinci made minor corrections to other artists' theories on perspective. According to Leonardo, as objects in a painting are made to recede into the distance, the degree of detail should diminish and the colours should become less intense.

Leonardo developed the use of **sfumato**, a technique that created a smooth transition between different areas of colour and tone in a painting. Sfumato was essential for the development of a realistic sense of perspective. Through the use of careful shading, Leonardo achieved the illusion of depth on a two-dimensional surface.

As a result of these developments, art became recognized as a science and an intellectual activity during the Renaissance. Artists gained social standing; no longer considered merely craftspeople, they were intellectuals.

The artists who gave birth to the Renaissance considered it to be a new era that was morally and culturally superior to earlier times. In order to justify their new practices, artists began to write theories about art and its relationship to the natural world. The creation of art was seen as a logical, scientific process.

Alberti was the most successful spokesperson for the belief that art was a branch of science. He believed that artists should study nature and attempt to establish rational, theoretical, and practical rules about the natural world. Both science and art used rules of proportion based on geometry and arithmetic. To Alberti, it was clear that art was an intellectual activity.

During the Middle Ages, the teaching of the practical aspects of art occurred in workshops, where apprentices worked under a master artist. The change in the status of the artist during the Renaissance allowed artists to train apprentices not only in the technical aspects of art, but also in geometry, anatomy, botany, and optics.

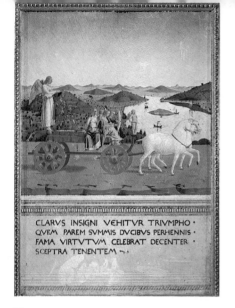

CLARVS INSIGNI VEHITVR TRIVMPHO ·
QVEM PAREM SVMMIS DVCIBVS PERHENNIS ·
FAMA VIRTVTVM CELEBRAT DECENTER ·
SCEPTRA TENENTEM

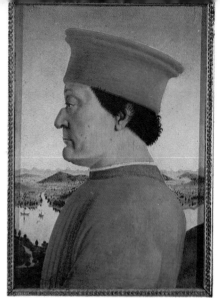

Patronage

None of this creative activity would have been possible without the support of patrons. Financial support for the artist, or patronage, had always existed, but during the Renaissance, the relationship between the patron and the artist went beyond the financial. Not only did the patron finance artistic projects that fulfilled civic, religious, or political needs, but he also financed works that would increase his standing in the community and glorify him and his family. The patron was not just making a donation when he financed an artistic project, he was becoming an actor in history. The patron and his family began to appear in paintings as active participants, even when the subject matter was religious. Patrons no longer appeared in paintings as small figures that blended in with the scene, as they had in the Middle Ages. Patrons became figures with a dual role: representing real people in history and playing characters in the story that the picture was telling.

PIERO DELLA FRANCESCA. *The Duke of Urbino.* **1480. Uffizi Gallery, Florence, Italy.** In this scene, the duke, surrounded by figures representing the Virtues, is shown in a chariot drawn by two white horses. A figure representing Victory stands behind him and places a crown on his head as Cupid holds the chariot's reins. The chariot is a vehicle of triumph and the horses represent gallantry. The Virtues indicate that the duke is a husband— with Cupid, or Love, as his guide. The verse on the scene proclaims the duke's fame. In the portrait of the duke on the reverse, a landscape background represents part of his lands.

13

With the appearance of this new type of middle-class or aristocratic patron, the church ceased to monopolize the control of artistic production. Ownership of works of art helped to signal and confirm the social status of a family. Art became a luxury associated with the bourgeoisie, or middle class.

Commissions became a symbol of political, ideological, and social prestige. The most important families competed to commission works of art. This in turn increased artistic creativity. The European rulers—Francis I of France, Charles V of Spain, Henry VIII of England, and the pope—all employed leading artists of the day.

All this was possible because artists had become free of the medieval guild system that had once strictly controlled their work. Artists were now given a permanent contract by a patron. The artist either received a flat salary or was paid according to the size of his work.

In the Renaissance workshop, or *bottega*, a wide range of artistic activity was carried out—goldsmith work, painting, sculpture, decorations for festivals, and theatre sets. Frequently, several artists would collaborate on a project. But the originality and individuality of each artist increased in importance.

As artists across Europe became aware of the classical world, they took trips to Italy to study it. It became almost mandatory for artists to travel to Italy to gain the status of master artist. The increase in the production of prints and engravings also helped to transmit artistic techniques and subject matter to other countries and contributed to the gradual expansion of the Renaissance outside of Italy.

ARCHITECTURE

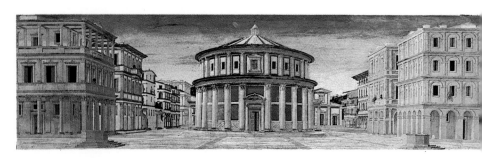

**FRANCESCO DI
GIORGIO MARTINI.**
The Ideal City. **c. 1475.
Galleria Nazionale delle
Marche, Urbino, Italy.**
The Renaissance city was
an ideal city in concept,
design, and desirability.
Martini was a painter who
also wrote treatises. His
design for an ideal city
shows the extent to which
it was planned with the
main buildings opening on
wide streets or squares.
This new concept of urban
planning was based on
humanism and models
from antiquity.

The Renaissance was a time when architectural theories were debated as never before. Architecture, dependent on logical rules, calculations, and techniques, provided the main means of assimilating art into the sciences.

An explosion of theories occurred primarily in the field of urban planning and the notion of the ideal city. The medieval city had been surrounded by walls for defence. The literal and symbolic centre of the city had been the cathedral. In contrast, the ideal Renaissance city was envisioned to be highly diversified: churches, houses of the wealthy, hospitals, and centres of learning would line broad streets and squares. Except for small sections of Piacenza and Cremona, Italy, this type of city never existed, but remained a dream.

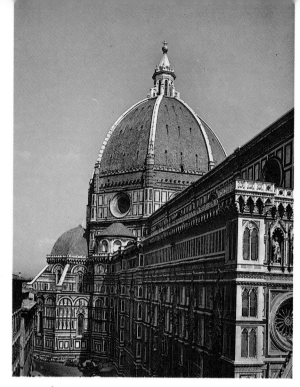

FILIPPO BRUNELLESCHI. Florence Cathedral. 1418. Florence, Italy.
Brunelleschi was the son of a Florentine notary and studied the liberal arts and mechanics. His mechanical knowledge enabled him to succeed at one of the greatest architectural challenges of his time: the construction of a dome almost 140 feet (42 metres) in diameter for the cathedral in Florence. He planned the dome using mathematical calculations and used new techniques to build it. His dome was to provide a transition between the Gothic style of the rest of the cathedral and the new forms that had been revived from antiquity. The dome was raised without supports. It is a self-supporting, double shell that uses an internal support system and bricks arranged in a herringbone pattern for added strength. Brunelleschi's dome announced a new approach to architecture. Ever since its erection, it has been a symbol of the beauty of Florence.

While complete Renaissance cities were never built, architects did build a large number of buildings based on the Renaissance ideal. Architecture followed two basic principles: it used formal elements drawn from antiquity and it followed the rules of perspective. The formal elements architects used—**columns, pilasters, capitals, entablatures,** and **arches**—were modelled on pieces from antiquity and the

FILIPPO BRUNELLESCHI. Ground plans. Church of San Lorenzo. 1421-29. Church of San Spirito. 1434-35. Florence, Italy. San Lorenzo and San Spirito reveal the Renaissance concern for the ideal, centralized ground plan. While it was occasionally used in churches, the plan was never popular and remained a concept rather than a reality. The basilican plan was used more widely because the longitudinal layout allowed different services to be held in the side chapels and at the main altar at the same time.

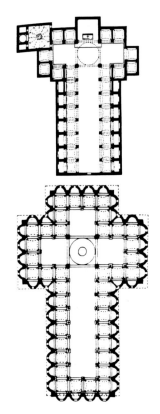

writings of Vitruvius. These structural elements were used to make walls and open spaces easily apparent and to create a sense of perspective within buildings. In early Renaissance buildings, each element was modelled on the antique, but the early buildings lacked the sense of unity that classical structures had had. At the end of the 15th century, Bramante and Michelangelo introduced a greater sense of coherence to Renaissance architecture.

Renaissance architecture, with its classical elements, looked very different from Gothic architecture. Medieval Gothic buildings were considered unnatural by Renaissance writers. Renaissance architects used a Roman building system. Walls, which had been replaced with large, stained-glass windows in medieval buildings, became solid surfaces again. These walls both supported and enclosed space and were

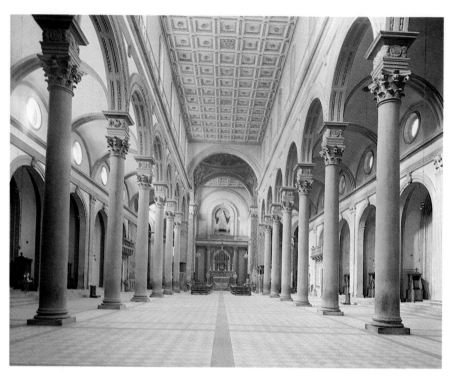

FILIPPO BRUNELLESCHI. Church of San Lorenzo. 1421-29. Florence, Italy.

Brunelleschi used a basilican ground plan with three aisles to create a space in which lines converged according to the laws of perspective. The treatment of space and the simplicity of the decorations are in harmony with the overall proportions of the church and create a great sense of clarity and coherence. The feeling is accentuated by the overhead lighting, which illuminates the central aisles. They resemble streets or arcades opening on a square as found in the ideal Renaissance city.

either covered with a coloured marble facing or left in their plain, **rusticated** form.

Renaissance architects constructed their buildings according to theoretical guidelines. However, often theory and practice did not meet. The practical requirements of the actual construction and use of a building often reduced the opportunities for architects to be faithful to the theories. In practice, many variations that distinguished

Renaissance buildings from those built during the Middle Ages were more decorative than structural.

Churches, Facades, and Cloisters

Renaissance architects used two types of plans to build churches and related buildings: the basilican (or longitudinal) plan and the centralized plan.

The basilican ground plan, which took the form of a Latin cross, was based on models of churches in Tuscany, such as the Pisa Cathedral. This basic shape—a cross whose upright bar is longer than the crossbar—was later used by Brunelleschi for the churches of San Lorenzo and San Spirito. Both of these **basilicas** have three aisles, arches supported by columns, and a **cupola**, or domed roof, over the crossing. Brunelleschi's innovations included a flat roof over the central aisle (this had been **vaulted** in medieval churches), columns that lined the central aisle, pilasters that divided the walls along the side aisles, and entablature above the pilasters. At San Spirito, Brunelleschi continued the side aisles around the crossarms, or **transepts**, and **apse**, creating a strong sense of unity in the church. This idea was frequently repeated with minor variations in other churches.

The ideal Renaissance church, however, had a circular or centralized ground plan. The attraction of this layout was based on geometric and religious ideas. The circle was considered the most perfect geometric form, and as such was

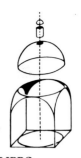

FILIPPO BRUNELLESCHI. The Old Sacristy. Church of San Lorenzo. 1428. Florence, Italy. Diagram showing centralized ground plan.
Here, Brunelleschi uses basic geometric forms in his formula for the sacristy. The ground plan is a perfect square. Projected in three dimensions, it becomes a cube. The arches, forming four **pendentives** (the triangles between the arches), support a circular drum and a dome, which is topped by a cupola.

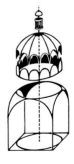

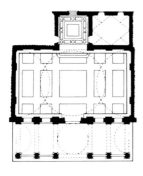

FILIPPO BRUNELLESCHI. Ground plan of the Pazzi Chapel. 1430-33. Florence, Italy.
The chapel was designed with an outside porch, which has a dome over the doorway. Despite the rectangular plan, Brunelleschi centralized the interior of the chapel with a small shadow dome that is scarcely visible from the exterior.

thought to be the work of God. Another type of centralized ground plan used in Renaissance churches was the shape of the Greek cross, in which all four arms of the cross are of equal length.

MICHELANGELO BUONARROTI. Dome of Saint Peter's. 1561-90. Rome, Italy.
The dome at Saint Peter's, when it was first designed, was a prototype for all circular construction during the Renaissance. It is one of the most representative and widely recognized pieces of Renaissance architecture, because it is both the centre of and a symbol for Catholicism and the pope.

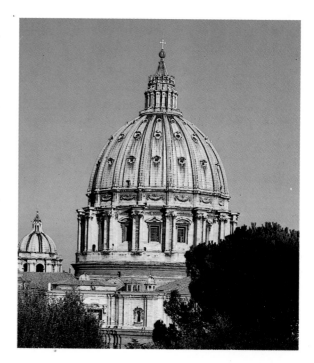

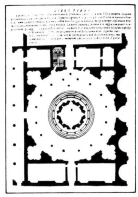

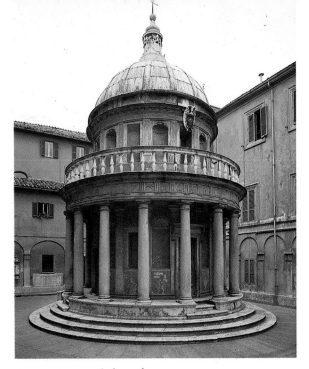

DONATO BRAMANTE. Tempietto de San Pietro in Montorio. 1502. Rome, Italy.

Bramante was the first Renaissance artist to use the classical style. This style emphasized the structure and the volumes of the individual parts of a building. Bramante combined his firsthand knowledge of Roman ruins and his concern for the correct interpretation of Vitruvius's books on architecture in this *tempietto* (little temple). It expresses a unity of idea and form. Its centralized ground plan is a perfect example of the ideal Renaissance structure. The horizontal and vertical forms of the tempietto are balanced because of the building's circular shape. The circular colonnade and niches on the wall give the building a sense of volume and rhythm.

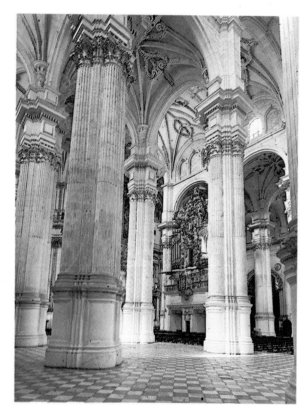

**DIEGO DE SILOÉ.
Granada Cathedral.
1528. Granada, Spain.**
In Granada, Siloé built a
Renaissance cathedral on
the earlier Gothic founda-
tions. He used both a
basilican plan for the nave
and a centralized plan for
the apse, where, because
of the arrangement of
columns and piers, atten-
tion is focused on the altar.

**LEONE BATTISTA
ALBERTI. Church of
Santa Maria Novella.
1456-70. Florence, Italy.
Diagram of the facade.**
Santa Maria Novella clearly
demonstrates the Renais-
sance love of geometry and
proportion. The compo-
sition of the facade is based
on a square divided into
two rectangles—the upper
and lower halves of the
facade—that in turn are
divided into squares. The
proportions of the facade
give it a sense of rhythm
and balance.

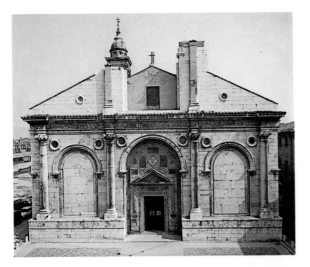

LEONE BATTISTA ALBERTI. Facade of the church of San Francisco. 1446-50. Rimini, Italy. In this **facade**, Alberti demonstrated his practical understanding of Roman architectural design. He successfully joined the Renaissance emphasis on idea with classical forms. The facade is in the form of a triumphal arch.

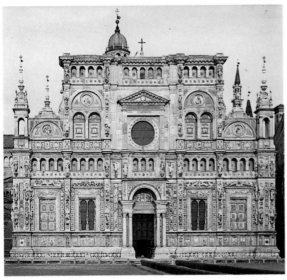

GIOVANNI ANTONIO AMADEO. The Charterhouse. 1491-98. Pavia, Italy. The Charterhouse was built with money given by the wealthy merchant families, Visconti and Sforza. Amadeo was the best of a large group of artists that worked on the building. Elements of Gothic architecture are given a new interpretation. In contrast to the usual Renaissance practice of emphasizing a building's structure, here, the large and elaborate decorations seem to hide and even dissolve the building's structure.

PIETRO LOMBARDO. Church of Santa Maria dei Miracoli. c. 1480. Venice, Italy.

Santa Maria dei Miracoli illustrates how the ideas of the Florentine Renaissance of the 15th century—the quattrocento—were interpreted in Venice. Architects there used more decoration on their buildings and incorporated Gothic elements into classical models. Here the horizontal and vertical elements of the walls and the facade are harmoniously balanced and decorated with multicoloured marble.

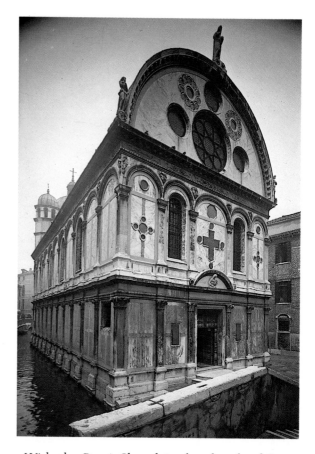

With the Pazzi Chapel in the church of Santa Croce in Florence, Brunelleschi established another precedent. The chapel is a rectangular structure, like a medieval building, but the domed roof imposes a circular form on the space. The visual impression is reinforced by the use of bright colours and classical ornaments: shells, fluted pilasters, winged cherub heads, and medallions sculpted in shallow relief.

Bramante built the epitome of the centralized Renaissance building in the Tempietto de San Pietro in Montorio, which was constructed in 1502 to mark the spot on which Saint Peter

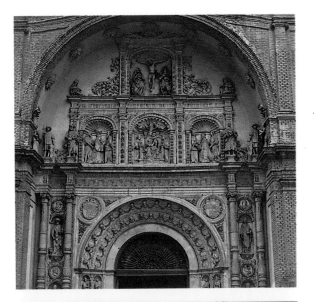

GIL MORLANES. Facade of the church of Santa Engracia. 1519. Sargossa, Spain.
JUAN DE ALAVA. Salamanca University. 1530. Salamanca, Spain.
Spanish architects experimented with the designs of facades. Both Santa Engracia and Salamanca University have **plateresque** facades: the amount and richness of the decoration resembles the work of the Spanish silversmiths. The facade of Santa Engracia introduces new architectural elements from Lombardy. The retable over the doorway depicts scenes from the Virgin Mary's life. In the facade of Salamanca University, Álava used a triumphal arch, dedicated to Charles V. Its decorations illustrate the humanist themes of monarchy, antiquity, and religion.

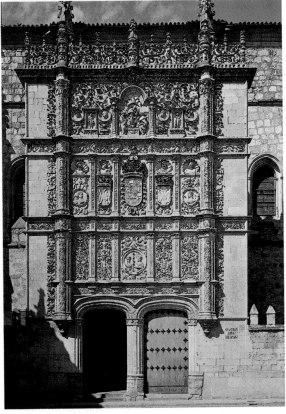

JUAN DE VALLEJO. Arch of Santa Maria. 1553. Burgos, Spain.
This fortified entranceway to the city of Burgos was built in the form of a triumphal arch commemorating Charles V. A statue of Charles as emperor is surrounded by statues of local nobles and officials being watched over by guardian angels and the Virgin Mary. The decoration of the arch provides a key to the character of the city as a political, religious, and civic unit.

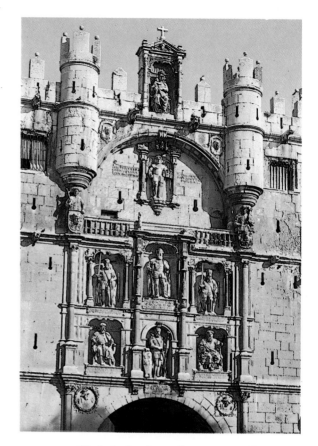

was crucified. In both its form (a small, round temple capped by a dome) and its function (a commemorative chapel), it expresses the ideals of the Renaissance.

The project that brought together the greatest architectural efforts of the Renaissance and employed the most important architects of the era was Saint Peter's in the Vatican. Bramante, Raphael, Peruzzi, and Michelangelo each was involved in the design of the church. Michelangelo reconciled the centralized and longitudinal church plans by using a dome to centralize the entire space.

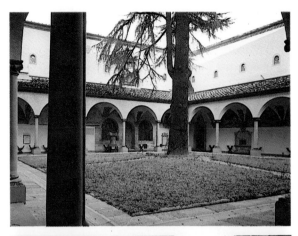

**MICHELOZZO MICHELOZZI. Cloister of San Marco. 1437. Florence, Italy.
DONATO BRAMANTE. Cloister of Santa Maria della Pace. 1504. Rome, Italy.
PEDRO DE IBARRA. Courtyard of the Fonseca Palace. 1545. Salamanca, Spain.**

Cloister architecture evolved from the simplicity of San Marco with its plain, rounded arches and simple columns to a system in Santa Maria della Pace that followed the classical model of a Roman amphitheatre. Pillars on the ground level supported rounded arches and alternating pillars and columns on the next level supported a flat **architrave.** In Spain, courtyards were widely built and the architectural elements used were less severe. For the courtyard of the Fonseca Palace, Ibarra used medallions, lamps, and intricately carved balustrades and column capitals.

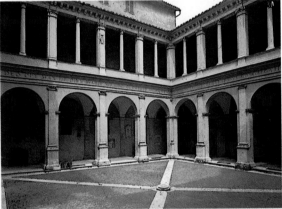

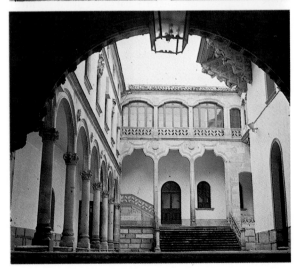

The debate about the form a church should take mattered little outside of Italy. In the rest of Europe, the clergy in power were more conservative and preferred to continue building Gothic churches. They felt that the proper arrangement for a church was the traditional basilican plan with side chapels, transepts, and apse, which was usually used in cathedrals. However, the Spanish architect Diego de Siloé made limited use of the centralized ground plan in important projects such as the Granada Cathedral.

Church facades, or fronts, made up a large part of the work of architects and sculptors. The design and style of a facade sometimes matched the space that lay behind it, but at other times it was treated independently.

Alberti redesigned the facade of the church of Santa Maria Novella in Florence (1456-70), incorporating the form of a Roman triumphal arch into the lower section of the facade and that of an antique temple above it. He joined the two sections with **volutes**, scroll-shaped ornaments that became very popular and continued to be used in Baroque architecture in the 16th and 17th centuries.

MICHELOZZO MICHELOZZI. Palazzo Medici-Riccardi. 1444. Florence, Italy.

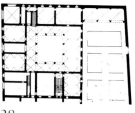

Michelozzo was one of the most representative artists of the Florentine quattrocento. He was in the service of the Medici family, the rulers of Florence. The Palazzo Medici-Riccardi is one of Michelozzo's most important works. It is a massive rectangular building, whose walls enclose a courtyard and the rooms around it.

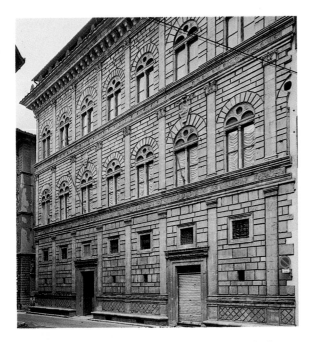

In Spain, architects used the Italian style from Lombardy, which emphasized decoration over the clear expression of a building's structure. This idea was introduced gradually, starting with the decoration of windows and doorways. As decoration began to spread over more of the building, facades began to be called retable-facades, because they resembled the decorated wall behind the altar in a church, called a **retable**. Retable-facades were widely used in religious and civic buildings in Spain.

Popular in monasteries during the Middle Ages, **cloisters** continued to be built during the Renaissance. Their style changed, however. The Gothic style used in medieval cloisters was replaced by the classical style and the design became simpler and more unified. The cloister—an enclosed courtyard surrounded by a covered walkway—was an important place in religious buildings, schools, hospitals, and even palaces.

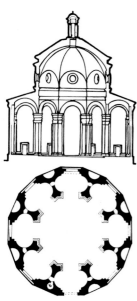

FILIPPO BRUNELLESCHI. Ground plan of the church of Santa Maria degli Angeli. 1434-37. Florence, Italy.
Brunelleschi, inspired by the round, Roman temple, the Pantheon, designed a centrally planned church. Santa Maria degli Angeli is designed in the form of two concentric circles. There are eight **piers** in the inner ring that support the dome and help define the eight interconnected chapels. The outer ring is 16-sided and contains the chapels.

The finest examples of Renaissance cloisters are the Vatican cloisters, designed by Bramante.

Palazzos and Hospitals

Rich, middle-class families, as well as the nobility, built elaborate and beautiful villas in the country and **palazzos**, or town houses, during the Renaissance.

During the Middle Ages, the castle was a symbol of feudal nobility. However, during the Renaissance, the palazzo became the symbol of the "urban lord." While a castle was heavily fortified, the palazzo was a town house in the form of a cube. Large windows looked out onto the street, and large and spacious rooms opened off an inner courtyard. The first architect to build a palazzo was Michelozzo, a pupil of Bramante. He used the lessons he learned from his teacher to build the Palazzo Medici-Riccardi (1444) in Florence. The building is square and has three storeys. The windows on the outside walls are aligned vertically to give the building a rational, organized appearance. The rooms are arranged around a central courtyard. The same model, with minor variations, was repeated throughout Tuscany during the 15th century.

Throughout Italy, France, and Spain, residences were built for the monarchy, ruling class, and bourgeoisie. In Rome, palazzos were more classical in appearance. In Venice, because of the climate and setting, the facades were more decorative so reflections of the water would create

interesting patterns on the walls. Outside Italy, local architects built versions of the Tuscan palazzo. Spanish architects in particular paid greater attention to the decoration of the building than to the logical and clear expression of its structure.

Another important type of architecture during the Renaissance was the country house, or villa,

Although Naples did not develop its own style of Renaissance architecture, this entranceway represents an attempt to adapt Renaissance forms onto an earlier building. The triumphal arch was built between two medieval towers and used classical forms—relief carving, entablatures, statues, and columns—to proclaim the greatness of Alphonso V.

LUCIANO LAURANA. Entranceway to the castle of Alphonso V, the Magnificent. 1461-70. Naples, Italy.

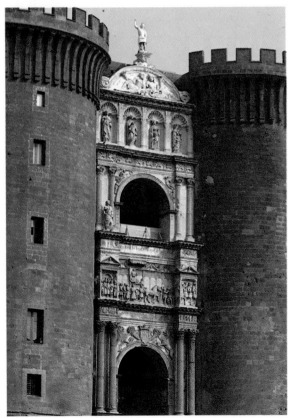

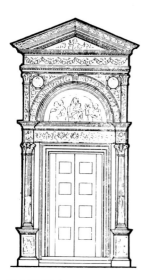

which had also been built during antiquity. During the Renaissance, villas were built with towers at the corners for defensive purposes. The villas were situated so that their owners had views of the countryside or extensive gardens. These houses served as models for later country palaces built by powerful monarchs.

Many hospitals were also built during the Renaissance. Hospitals were often joined to convents, because hospitals of the times were run by nuns. Renaissance architects theorized about what form hospitals should take. They felt the buildings should express the relationship between religion and medicine. Often they were designed in the form of a cross with a chapel in the centre so that the sick could attend services.

DOORWAYS AND WINDOWS.

Doorways and windows were built according to models taken from antiquity. In doorways, pilasters and half columns supported an entablature above which there was a triangular or semicircular **pediment**. The area inside the pediment was used for a variety of decorations that were often based on

classical themes. Window openings were also decorated with classical forms and were thought of as niches in which people were framed as if they were living sculpture.

SCULPTURE

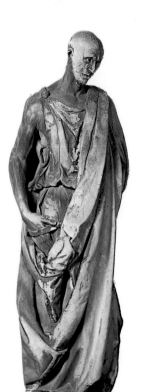

DONATELLO.
The Prophet Habakkuk.
**1436. Cathedral Museum,
Florence, Italy.**
Donatello carved five
prophets from the Bible
for the bell tower of the
Florence Cathedral
between 1418 and 1436.
The statue of Habakkuk
displays a high degree of
vitality and life. The
modelling of the perfectly
proportioned arms con-
trasts with the folds of the
garments, which convey a
dramatic sense of volume.

The search for an ideal representation of the human body led Renaissance artists to study anatomy and the way the body moved through space. They studied anatomy using both live bodies and corpses. Artists also devised systems of proportion for the relationship between different parts of the body. Sculptors followed the classical rules of Polyclitus, which dictated that the height of nine or ten heads should make up the length of the human body. In addition, sculptors were influenced by antique sculptures such as the *Apollo Belvedere* and the *Laocoön*.

Donatello displays a high
degree of realism, especially
in the statue's face and
bald head.

**LORENZO GHIBERTI.
Baptistry doors. 1425-52.
Florence Cathedral.
Florence, Italy.**
In these doors, called the
"Gates of Paradise,"
Ghiberti fully integrated
the background space into
the scene. The ten scenes
depict biblical themes. The
landscape and architecture
make up settings in which
the figures seem to occupy
real space. To achieve a
sense of volume and depth,
Ghiberti used pictorial
methods and the sculptural
techniques that made these
possible—casting, chisell-
ing, and gilding bronze.
These were part of the
important artistic tech-
niques developed in
Ghiberti's workshop, in
which a large number of
Florentine artists trained.

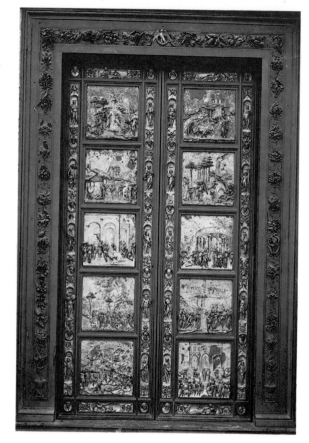

During the quattrocento, sculpture had a great
influence on painting. Many painters began their
careers as sculptors and goldsmiths and used
sculptural models in their paintings.

Sculptors used a wide variety of materials in
their works, including stone, marble, wood,
terra-cotta, plaster, and bronze. They sculpted
these materials into statues, portrait busts, and
relief carvings. Subject matter was varied, but the
most popular subjects were religious, historical,
or mythological scenes.

Sculpture of the early Renaissance reached
its climax with the three sets of doors of the

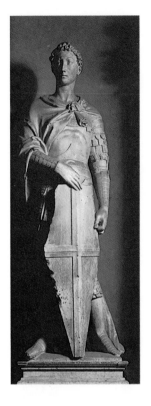

DONATELLO. *Saint George.* **Pedestal relief. 1415. Church of Orsanmichele, Florence, Italy.**

The statue of Saint George (left) is one of Donatello's best known and most admired sculptures. The figure stands at attention and appears very watchful, as if he could spring into action at any moment. His face seems to express an inner strength. Donatello conveys a sense of vigour and movement. Saint George's fight with the dragon is depicted on the base of the statue (below). Although the scene is sculpted on a flat surface, Donatello uses perspective to make it appear real. The princess on the right leads the viewer's eye to the horse, which seems to disappear into the background. The fine modelling used to achieve this effect was invented by Donatello, and is called *schiacciato*.

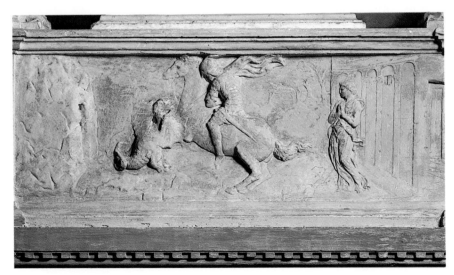

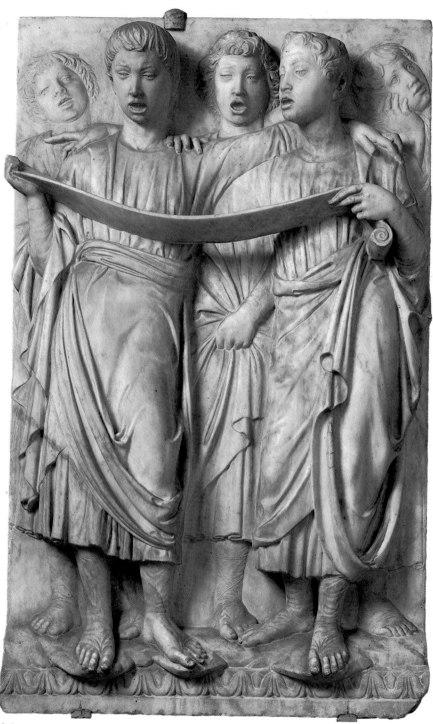

baptistry of the Florence Cathedral. Lorenzo Ghiberti completed the third set of doors in 1452. Beginning from the Gothic tradition, he created a new language of sculpture using soft modelling and elegant folds. He solved sculptural problems by using the pictorial methods of perspective,

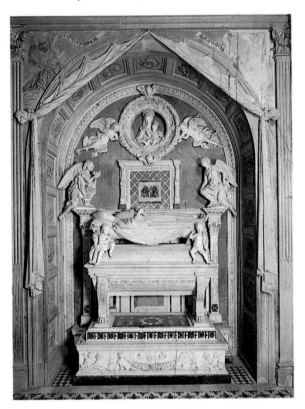

BERNARDO and ANTONIO ROSSELLINO. Tomb of the cardinal prince of Portugal. 1461-66. Church of San Miniato al Monte, Florence, Italy.
Tomb sculpture was very important during the Renaissance. Its purpose was to commemorate and exalt the deceased. In contrast to medieval tombs, which exclusively used Christian symbols, Renaissance tombs used allusions drawn from antiquity. The highest expression of this was the tomb of the cardinal prince of Portugal. The theme is a Christian one, but the components are taken from antiquity. The sarcophagus on which the prince rests, the scene on the base, and the whole form of the monument—a triumphal arch with the curtains drawn back—are classical. The only Christian symbol is the tondo, or medallion, of the Virgin and Child supported by angels above the prince.

LUCA DELLA ROBBIA. *Singing Gallery*. 1431. Florence Cathedral, Florence, Italy.
Luca della Robbia was the first of a group of sculptors that made brightly coloured clay sculptures. He also worked in marble and created stately and elegant sculptures. *Singing Gallery* (opposite) depicts a group of choir boys whose graceful bodies seem to sway in time to the music they sing. Della Robbia paid careful attention to details to convey a sense of liveliness and relaxation.

ANDREA DEL VERROCHIO. *Colleone.* **1479. Piazza San Giovanni e Paolo, Venice, Italy.**
While the first generation of Renaissance sculptors perfected bronze casting techniques and explored the pictorial possibilities of relief sculpture, the second generation moved in new directions. In his statue of Bartolomeo Colleone, Verrochio sought to express movement, depth, and solidity and to accentuate anatomy. This equestrian monument, which stands in a public square, has a strong three-dimensional presence.

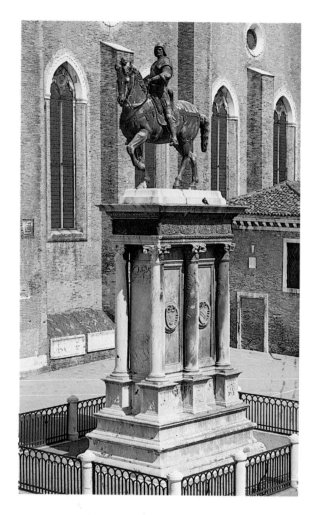

anatomy, composition, and movement. Michelangelo said these doors were worthy of being called the "Gates of Paradise."

The sculptor Donatello was more interested in representing the single human figure than he was in compositions, such as Ghiberti's baptistry doors, that involved numerous figures. Donatello's statues for the campanile, or bell tower, of the Florence Cathedral, and his figure of Saint George for the church of Orsanmichele,

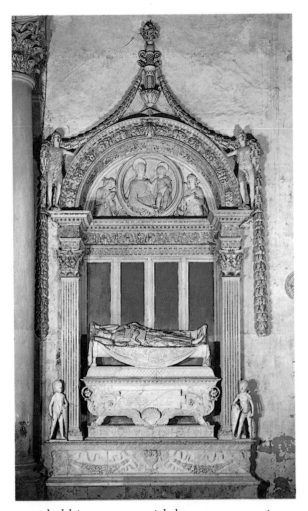

DESIDERIO DA SETTIGNANO. Tomb of Carlo Marsuppini. After 1453. Church of Santa Croce, Florence, Italy. Desiderio da Settignano set a precedent for tomb design with a rich and decorative style in this retable tomb. It has a strong three-dimensional quality, and the decorations include elements of flattery and praise: heraldry, garlands, scrolls, and figures of the Virtues taken from mythology.

revealed his concern with human expression. His skill at portraying the expressiveness of the human face also was evident in his portrait sculptures, which convey a strong sense of the personalities of the sitters.

The followers of Donatello developed a softer style. The brothers Bernardo and Antonio Rossellino carved the tomb of the cardinal prince of Portugal in the church of San Miniato al Monte between 1461 and 1466. The tomb is in the form

ANTONIO POLLAIUOLO. Tomb of Innocent VIII. c. 1495. Church of Saint Peter's, Rome, Italy.

Pollaiuolo's tomb of Innocent VIII was the first to depict the dead person as he was in life. Here, Innocent sits on a throne wearing his papal robes. On the retable surrounding the figure, there is a set of relief sculptures praising him. Along the top, presided over by Charity, are the Virtues, and on the sides are figures representing the arts and sciences. Clearly, these figures represent qualities that Innocent VIII possessed and were meant as the highest praise that could be given.

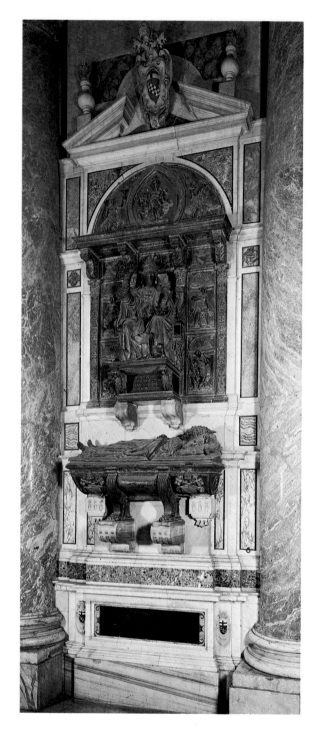

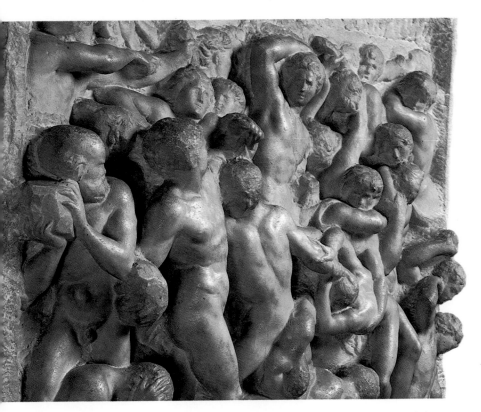

MICHELANGELO BUONARROTI.
The Battle of the Centaurs.
1492. Casa Buonarroti Museum, Florence, Italy.
Even in his earliest works, Michelangelo displayed his mastery of the material with which he worked.

The theme of a piece became unimportant to Michelangelo as he sought to express his inner struggles in artistic form. Here, in an unfinished piece, Michelangelo depicts a young man with his arm raised. Around him, nudes in various poses—fighting, twisting, and turning—all show the beauty of the human form. The polished foreground figures give way to sketchy nudes in the background, who seem trapped in the stone, but convey a sense of depth and distance. Michelangelo could have learned the technique from Donatello and Ghiberti.

of a great arch that holds a sarcophagus and is decorated with classical elements. Desiderio da Settignano used a similar style in his tomb of Carlo Marsuppini and also used decorations taken from antiquity. Luca della Robbia worked in clay, producing glazed ceramic and terra-cotta

41

MICHELANGELO BUONARROTI. *David.* **1501-04. Galleria dell'Accademia, Florence, Italy.**

David has become a symbol of human perfection. Michelangelo concentrated on the human body in all its beauty of proportion and line. He dispensed with or hid the attributes that identify David as a shepherd and fighter of the king — freeing the figure from all biblical allusion. Because of the majesty of the figure, it is still copied and used as a model by artists, as it has been for almost 500 years.

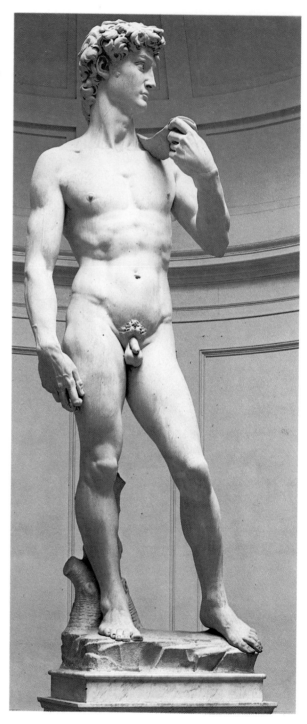

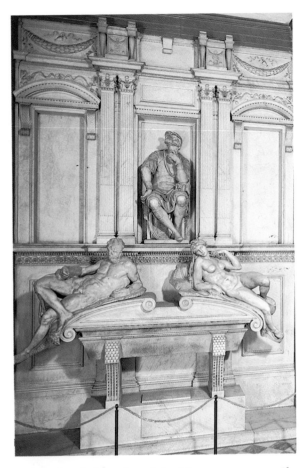

MICHELANGELO BUONARROTI. The Medici Tombs. 1520-34. The Medici Chapels, Florence, Italy.
Michelangelo worked on the two tombs for Lorenzo, the duke of Nemours, and Giuliano, the duke of Urbino, intermittently from 1520 until 1534. In these tombs, all Christian symbolism is gone. The allegorical figures of Day and Night and Dawn and Dusk are drawn from classical mythology. The dukes are dressed as Roman military figures.

pieces brightly painted in blues, greens, and whites. They were very popular and sold well. His workshop was later taken over by his sons Andrea and Giovanni della Robbia, who continued to work in their father's popular style.

The sculptors who trained in Andrea del Verrochio's workshop learned a style that stressed realism. This can be seen in Verrochio's *Colleone* in Venice. One of his students, Antonio Pollaiuolo, worked mainly in small formats, producing highly expressive plaquettes and statuettes that were full of movement. Pollaiuolo also executed large-scale works, such as the tomb

of Innocent VIII in Saint Peter's in the Vatican.

Michelangelo was the master of sculpture during the High Renaissance. He learned from the work of Donatello and studied antique models in the Medici art collection. In his earliest works, Michelangelo translated his emotions and spirituality into classical form. His most profound works are the *Pietà* (1497) in Saint Peter's and the *David* (1501-04). His Medici Tombs (1521) demonstrate that for Michelangelo, there was no idea that could not find expression in marble.

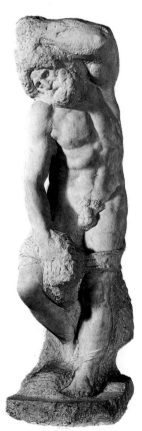

MICHELANGELO BUONARROTI. *Dying Slave.* **1519-36. Galleria dell'Accademia, Florence, Italy.**
Michelangelo's slaves, originally conceived of as part of the tomb of Pope Julius II, are an allegory of humanity made prisoner, handcuffed, and enslaved by passions and uncertain destiny. The slaves appear to be trapped in the blocks of marble out of which they emerge, expressing perfectly their desire to escape from this imprisonment. Once again, Michelangelo expressed sets of dualities: matter and spirit; death and life; slavery and freedom.

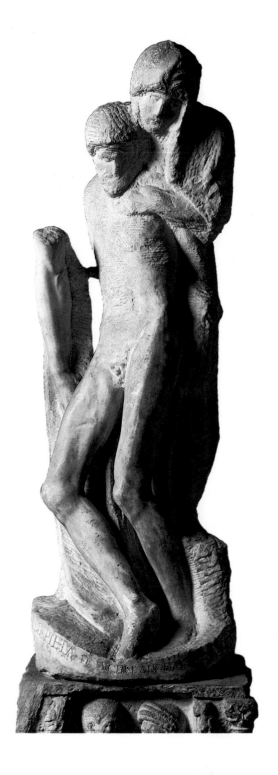

**MICHELANGELO
BUONARROTI.
Rondanini *Pietà*. 1554.
Museum of the Sforza
Castle, Milan, Italy.**
Sculptures of the Pietà
traditionally show the dead
Christ in the lap of the
Virgin Mary. Michelangelo's
Pietà is highly unusual
because Mary and Jesus are
both shown standing. It is
as if Michelangelo was
unsure who was support-
ing whom. The anatomy of
the figures was reduced to
the essentials, the forms
are free, and the marble
seems to disappear.

BARTOLOMÉ ORDÓÑEZ.
The Martyrdom of Saint Eulalia. **1519. Retro-choir. Barcelona Cathedral, Barcelona, Spain.**
Ordóñez studied in Italy, where he gained knowledge of Michelangelo's work. He was the first Spanish sculptor to bring the Italian High Renaissance to Spain. On his return from Italy, Ordóñez settled in Barcelona, where he received a commission to enlarge the wooden **choir** and the ceremonial marble **retro-choir** of the cathedral. Although Ordóñez died before he completed the project, Michelangelo's influence can be seen. Ordóñez used a softer modelling technique and was more concerned with pictorial narrative, as can be seen in his background figures.

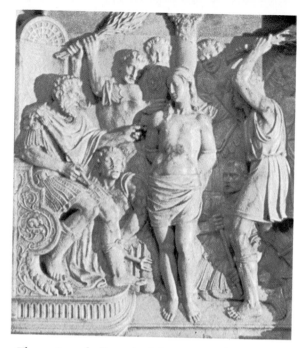

The pairs of allegorical figures on the tombs— Day and Night and Dawn and Dusk—express the vital duality of his thoughts and feelings; beginning and end, life and death. At the end of his life, because of his deepening sense of the mystery of faith, Michelangelo renounced perfection and physical beauty and created works in which the idea overwhelmed the form.

DAMIÁN FORMENT. High Altar. 1538. Cathedral, Santo Domingo de la Calzada, Spain.
Forment's many retables reveal a gradual shift from Gothic to Renaissance forms. This, Forment's final retable (opposite), is a definitive Renaissance composition. The carvings and ornaments foreshadow Mannerist sculpture, which is yet to come. The work includes a large number of mythical and classical themes, probably taken from engravings.

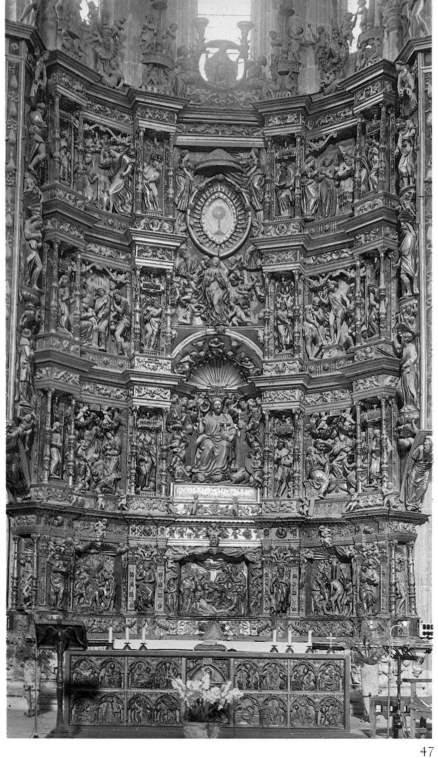

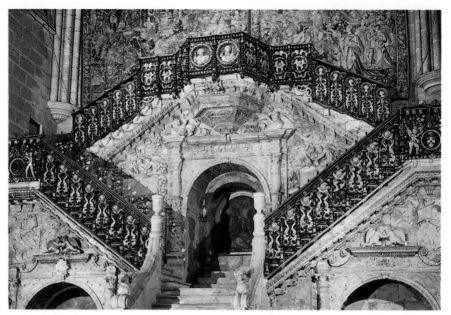

DIEGO DE SILOÉ.
The Gilded Staircase.
**1519-23. Burgos
Cathedral, Burgos, Spain.**
With the *Gilded Staircase*,
Siloé solved the problem
of the difference in levels
between the floor of the
Burgos Cathedral and its
north door. The staircase
is especially important
because it used the
complete ornamental
decoration that Siloé
introduced.

In France and Spain, sculptors developed a Renaissance style of their own. Important French schools were founded in Troyes and Paris. During the first half of the 16th century, many of the sculptors active in Spain were of French origin. However, the primary influence on Spanish sculpture was the work of the Italians. Spanish sculpture was largely made out of wood and was brightly coloured. The cities of Burgos and Avila were large artistic centres.

PAINTING

TOMASSO DI GIOVANNI MASACCIO. *Saint Peter Helping the Sick with His Shadow.* **1424-27. Brancacci Chapel. Church of Santa Maria del Carmine, Florence, Italy.**
This is one of Masaccio's most important works. It is part of a series of frescoes of the saints commissioned by the Brancacci family for their chapel in the church of Santa Maria del Carmine. Masaccio drew upon the architect Brunelleschi's system of perspective, on the modelling of the figures in Donatello's sculptures, and on his teacher Masolino's sense of colour to create a new style of painting. Masaccio knew how to use colour to give his forms volume. Rather than outlining the scene and then filling in the outlines, he created a series of planes out of colour and light, which give the scene depth.

The main purpose of a Renaissance painting was to tell a story. Artists believed that painting was the science of visualization of the world of the mind. Like poetry, painting required knowledge of a set of rules. Just as one had to learn to read poetry, one had to learn how

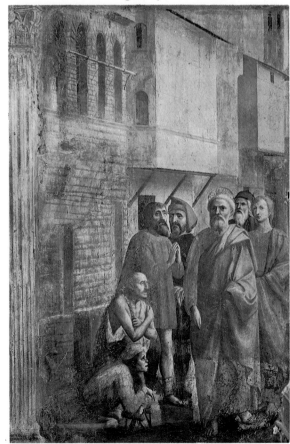

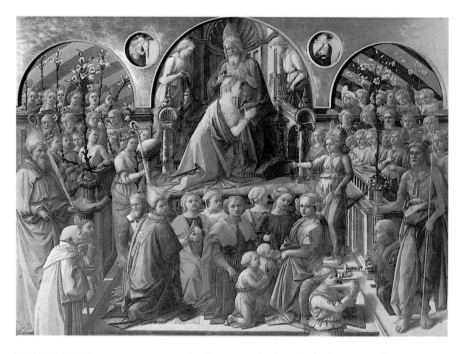

FILIPPO LIPPI.
Coronation of the Virgin.
**1445. Uffizi Gallery,
Florence, Italy.**
The scene shows the coronation of the Virgin Mary, with saints, angels, and people helping to celebrate. Lippi portrayed this as a scene from real life, combining a miniaturist painter's attention to detail, a strong sense of colour, and a degree of monumentality, which he inherited from painters before him. He organized the painting into a symmetrical composition that focuses attention on the action in the centre.

to look at a painting. Painting was silent poetry and poetry was painting for the blind. Both of them came out of the life of the mind.

A contract would be drawn up between the artist and client, which specified the design of the painting, the materials the artist would use and their costs, how much work the artist would do, and how much he could leave to the apprentices in his workshop. In Renaissance painting, the design or idea of a work was considered at least as important as the execution. Even ideas for paintings that were never produced were considered valuable. The artist was no longer just the craftsman he had been in medieval times, when artists repeated standard compositions countless times with only minor variations. During the Renaissance, the artist moved in status from that of a workman to that of a member of the middle class.

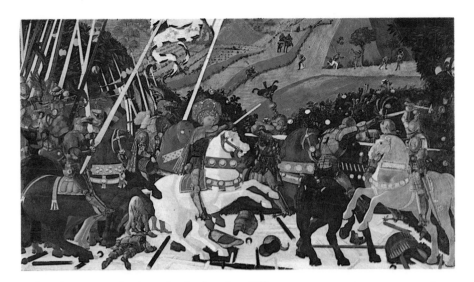

Renaissance paintings looked quite different from those produced during the Middle Ages. In medieval times, artists had not yet learned how to make space look realistic in a picture. Renaissance artists discovered a system of perspective that arose from the study of nature and antiquity. Artists paid attention to composition, space, volume, gesture, and lighting to create an entirely new type of painting.

Renaissance painting started in Florence with a diverse group of artists, often called the first generation, who worked during the first half of the 15th century. They included the monk Fra Angelico, Filippo Lippi, Domenico Veneziano, Paolo Uccello, and Andrea del Castagno.

One of the most important artists of the first generation was Masaccio. The frescos in the Brancacci Chapel in the church of Santa Maria del Carmine (1424-28) express Masaccio's concern with the plasticity of figures, his attention to composition, his interest in colour, and his attempt to depict a three-dimensional space which appeared to be real. The 16th-century writer Vasari

PAOLO UCCELLO. *The Battle of San Romano.* **1456-60. National Gallery, London, England.**
Uccello, who trained under Ghiberti as a sculptor and worked as a mosaicist in Venice, painted in the most intellectual and theoretical style of Florentine art. He followed in the footsteps of Masaccio, as *The Battle of San Romano* reveals. The horses, soldiers, and weapons appear stiff and wooden, as if they were shapes cut out of cardboard, and the background looks like a tapestry. Uccello was more interested in the correct theoretical use of artificial perspective than he was in the creation of a lifelike scene.

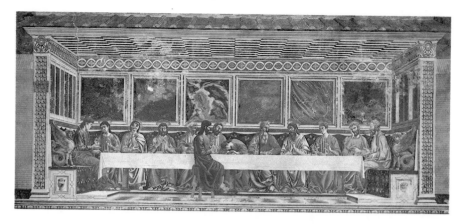

ANDREA DEL CASTAGNO. *The Last Supper*. 1448. Refectory of the monastery of Santa Apollonia, Florence, Italy.

In his paintings, Castagno combined the monumentality of Masaccio's figures, the realism of Uccello, and the plasticity of the garments in Donatello's works. *The Last Supper* is the only surviving fresco in the series he painted for the monastery of Santa Apollonia. Castagno depicted the scene in the Roman manner. The room in which the disciples and Jesus sit is painted to appear as if it were made out of marble. The figures themselves appear to be statues. Judas, who will betray Jesus, sits in front of the table, while the other disciples appear to be judging him. The theme of betrayal was thought to be an appropriate decoration for the refectories, or dining halls, of monasteries, because it reminded monks of the importance of faithfulness and obedience.

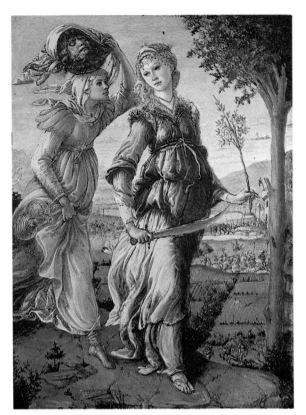

said that "with Masaccio the modern Renaissance style came into being."

These artists who worked in the second half of the 15th century are referred to as the second generation. Sandro Botticelli, Domenico Ghirlandaio, Filippo Lippi, and Leonardo da Vinci gathered in the workshop of the goldsmith and sculptor Verrochio to exchange ideas. Verrochio taught Leonardo how to model the human body, rocks, and space itself. Sandro Botticelli drew figures that possessed a dynamic elegance. He drew on mythology, humanism, and poetry for his subjects. Filippo Lippi introduced new decorative qualities. He painted allegories using a precise and lively style. Domenico Ghirlandaio, watched closely by his pupil Michelangelo, used antique

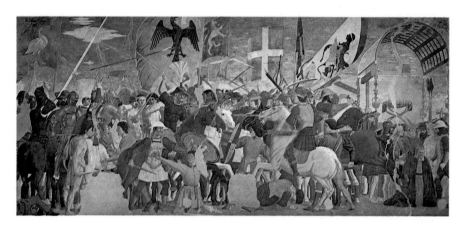

PIERO DELLA FRANCESCA.
The Victory of Heraclius over Chosroes **from** *The Legend of the True Cross.* **c. 1455-65. Church of San Francisco, Arezzo, Italy.**
Piero's fresco is a synthesis of works of the quattrocento. His feeling for colour came from Masaccio, Fra Angelico, and Domenico Veneziano. His sense of perspective came from Uccello. His figures are rounded and measured, like the columns of Brunelleschi's architecture. His carefully outlined and proportioned figures and his subtle use of colour and light contribute to a certain monumentality in this scene.

architectural forms and religious themes, in which the depiction of the patron was as important as the religious scene itself. Leonardo fused light and shade in his paintings by using sfumato, a

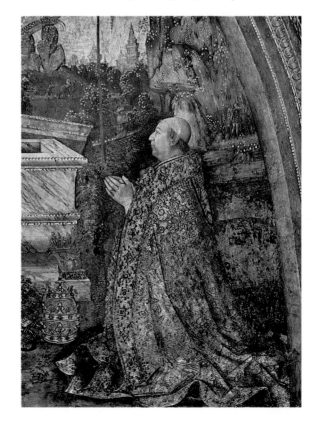

BERNARDO DI BETTO, IL PINTORICCHIO.
The Life of Aeneas Sylvius Piccolomini. **1503. The Piccolomini Library. Siena Cathedral, Siena, Italy.**
The Borgia Pope. **1492-95. The Vatican Apartments, The Vatican.**

Il Pintoricchio, in collaboration with young Raphael, painted these frescoes for the library of Aeneas Sylvius Piccolomini, Pope Pius II, who was a great Renaissance humanist. Recently restored to their original brilliance, the frescoes have a beautiful sense of colour, harmonious composition, and display the quattrocento decorative style. The soft colours and ornamental details help to construct the scene. The architectural elements in the work help establish the effect of recession into space and dissolve the wall surface. The portrait of Pope Alexander VI (opposite) gives an accurate portrayal of his character and displays Il Pintoricchio's virtuosity with decorative elements.

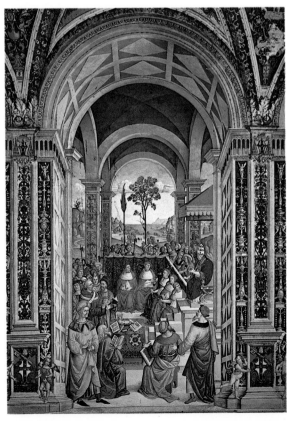

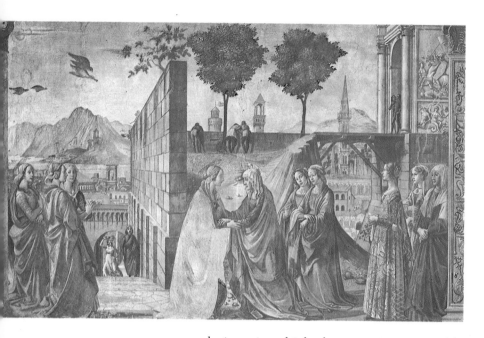

technique in which there are imperceptible changes of tone from light to dark, and objects seem to merge with the surrounding space. In Leonardo's hands, sfumato became a means to achieve visual and conceptual unity: figure and background, emotion and form, and soul and body—all were joined. This integration was the epitome of the High Renaissance style.

While Florence did produce a great number of outstanding painters, none of them shared a single style. Some were more conservative, others were more innovative, yet each contributed to the development of Renaissance painting. They all, in some fashion, were attempting to resolve questions of technique and ideology.

The technical question led to the application of mathematical theories to show movement, anatomy, and the placement of figures. Theories were developed for methods of visual representation, perspective, and rules of proportion based on the human body.

DOMENICO GHIRLANDAIO.
The Visitation of Mary.
1486. Church of Santa Maria Novella, Florence, Italy.
Ghirlandaio chronicled the everyday world of 15th-century Florence. Above all, he liked to incorporate figures of real people into his works, superimposing secular and religious themes. *The Visitation of Mary* (opposite), commissioned by the Florentine banker Giovanni Tornabuoni, is set in what could be the garden of any wealthy Florentine. The presence on the right of the Tornabuoni women and their governess is almost as important as the religious scene; it gives the women status and provides them with a double role as both participants and observers. This double role also implies the secularization of religious themes under the influence of humanism. In the work of Michelangelo, an apprentice of Ghirlandaio, the religious fused completely with the secular.

The ideological question was solved by the incorporation of historical and mythological themes with religious ideas inherited from the Middle Ages. Historical and religious events were represented as either real or allegorical. The

ANDREA MANTEGNA.
The San Zeno Altarpiece.
1459. Church of San Zeno, Verona, Italy.
More than any other artist of his generation, Andrea Mantegna respected the antique and wanted to restore the classical style. The drawing, colour, and lighting of the San Zeno Altarpiece give the figures the appearance of statues from antiquity. Mary and the Christ child sit on a throne in the centre and the saints are grouped around them. This type of scene is called a *sacra conversazione*, or sacred conversation. The pillars and **frieze** that Mantegna includes in the scene are classical. The scene is divided into three sections by the gilded, wooden columns of the frame, thus forming a **triptych**. Below the main scene there are three smaller paintings of the death and resurrection of Christ.

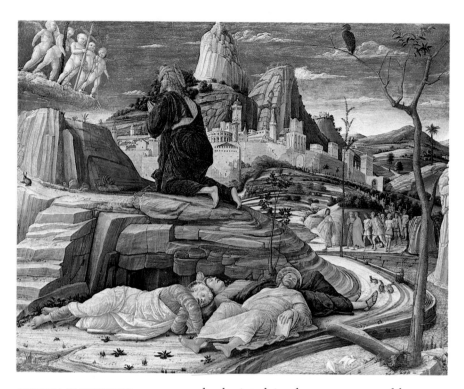

ANDREA MANTEGNA.
The Agony in the Garden.
**1455. National Gallery,
London, England.**
In this painting, the
disciples are shown sleeping peacefully. Christ prays
in a setting composed of
large rocks. In the background is the city of
Jerusalem. All the elements
of the painting—the fantastical rocky landscape,
animals, birds, and plants
—have symbolic Christian
meaning. The figures are
painted as if they were
statues made out of stone
rather than flesh. However,

people depicted in these scenes could appear
as themselves and as mythological, historical, or
religious characters. Often the scenes depicted
were full of allegorical, emblematic, or hieroglyphic symbols. A knowledge of religious and
civil history and mythology was required to
understand them.

Artists painted with a variety of materials. For
paintings on walls, they used the **fresco** technique. An artist would put a thin coat of wet plaster
on the wall and then paint on it. This created a
painting that was part of the wall and could not
be removed or erased. For paintings on wooden
panels or canvas, tempera (egg yolk mixed with
pigments) or occasionally oil paint was used.

Painters from other regions of Italy watched
the Florentine artists carefully. Piero della
Francesca was trained in Florence and in his

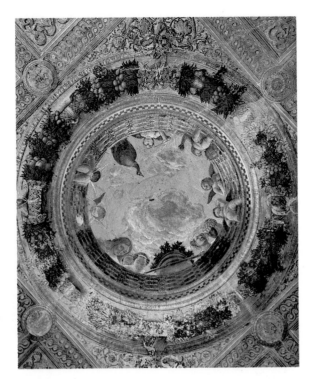

Mantegna shows his knowledge of the human body and perspective in the foreshortening of the sleeping figures in the foreground.

ANDREA MANTEGNA. Ceiling of the Camera degli Sposi. 1471-74. Ducal Palace, Mantua, Italy.

Ludovico Gonzaga, duke of Mantua, commissioned Mantegna to decorate the Ducal Palace. Mantegna's finest achievement was this painted ceiling. It was the first attempt by an artist to "break through" a ceiling using pictorial effects. The members of the Gonzaga family look down from a garden surrounded by birds, flowers, and winged cherubs, all under a deep blue sky. Mantegna used a complex system of foreshortening to make the scene appear realistic.

Legend of the True Cross he uses light to model the figures and architecture as a perspective device. In Perugia, a workshop formed around Pietro Vannucci, who was known as *Il Perugino*. Vannucci's shop used the Florentine advances. The workshop's use of colour and its harmonious compositions are displayed in the large murals of the Vatican: the Borgia Rooms by Il Pintoricchio (1492-95) and the Sistine Chapel, which Il Perugino and other artists worked on in the early 1480s.

In Padua, Andrea Mantegna, influenced by the Roman ruins, developed a monumental style. Artists came to study with him and soon the style spread throughout the region. The works of Cosimo de Tura, Francesco del Cossa, and Ercole Roberti show Mantegna's influence.

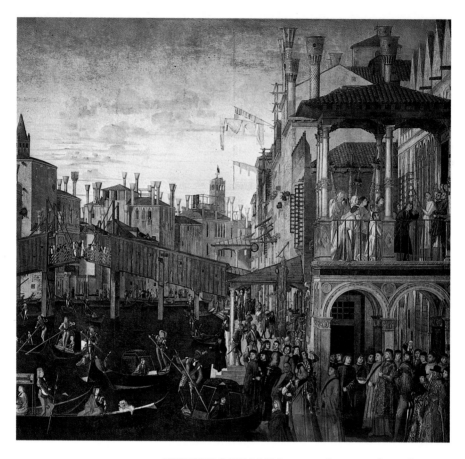

VITTORE CARPACCIO.
The Miracle of the Reliquaries of the Holy Cross. **1515. Galleria dell'Accademia, Venice, Italy.**

Carpaccio succeeded Gentile Bellini as the chronicler of Venetian life. He painted Venice's canals, squares, and palaces in minute detail. Here the city is the setting for a religious miracle, and the people throng the canals, bridges, and quays to witness it. The city's strange chimneys and gondolas are as much a part of the display as the clergy and the devout people who are dressed in solemn garments for the festival.

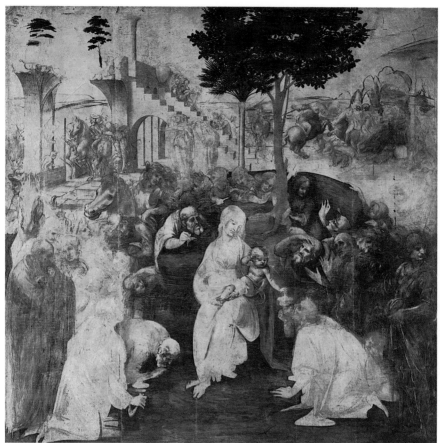

Mantegna's brothers-in-law, Gentile and Giovanni Bellini, worked in Venice and pursued two different styles. Gentile specialized in portraiture and cityscape narrative paintings. Giovanni took the advances in painting from Florence and adapted them. He used a naturalistic light and rich, glowing colour, combined with solid drawing and cleanly executed architectural perspective, to attain a unified composition in his paintings.

Humanism, the rediscovery of the antique, and Christian heritage were all reconciled at the beginning of the 16th century, during the High Renaissance, the fullest expression of Renaissance culture.

LEONARDO DA VINCI.
The Adoration of the Magi. **c. 1481. Uffizi Gallery, Florence, Italy.** This unfinished work is the epitome of High Renaissance painting. The composition is an arrangement of a series of concentric semicircles around the Virgin and Child. These both separate and unite the individual parts of the picture. The figures and space are in perfect harmony, as are the theme and form of the painting.

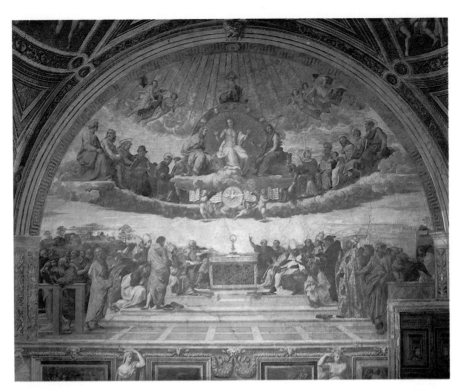

RAPHAEL SANZIO. *The Disputation Concerning the Blessed Sacrament.* **1509. Stanza della Segnatura, The Vatican.** Raphael painted four large frescoes in the Stanza del Segnatura, which express the complex relationship between classical learning and Christian theology. Here, church fathers, theologians, and doctors sit below, and correspond to, the figures in heaven. The figures are arranged in two semicircles, one celestial and the other human, as if they form the apse of a church.

At this time, Florence, long the centre for artists of the Renaissance, suffered political, economic, and cultural collapse, and Rome became the new artistic capital of Italy. Rome offered both the cultural climate and a circle of patrons that were favourable for Renaissance artists. During the High Renaissance, political and religious thinkers sought new ways to reconcile humanism and Christian doctrine. Patronage was largely papal: popes Julius II and Leo X used their economic power to make artists conform to certain standards in subject matter and execution.

Rome attracted some of the greatest artists of the Renaissance, including Raphael and Michelangelo. Raphael moved to Rome in 1508 and there he painted some of his greatest works.

In Rome, Raphael was commissioned by Pope

Julius II to paint the Stanza della Segnatura in the Vatican. There, he painted frescoes representing the four great faculties of the human mind: faith (*The Disputation Concerning the Blessed Sacrament*), reason (*The School of Athens*), law (*The Virtues*), and poetry (*Parnassus*).

Raphael's unique gifts as an artist come from his great technical abilities and from his training in the ideas of the Renaissance. He unified idea and execution in his works. His subject matter, the drawing of the figures, and the composition of the work, were all in harmony. He also was able to reconcile the tensions between antiquity and the Renaissance, and between Christian and non-Christian beliefs. His paintings and frescoes join the world of art and Christian morality.

Michelangelo also participated in the Roman High Renaissance. Although he considered himself a sculptor, he executed some of the most famous paintings of the Renaissance: the ceiling of the Sistine Chapel (1508-12) and *The Last Judgment* (1543-41). Like Raphael, Michelangelo sought unity in his forms. He carefully articulated the individual parts that made up this whole. For him, the subject matter of any work, such as the Doni Tondo (1506), became an excuse for recording his passionate response to the visual world, especially the human body. Any moral lessons that could be learned from his works were secondary. Michelangelo introduced the expression of psychological states into his paintings of the human form.

In Rome, Michelangelo worked on the decoration of the Vatican. When he was unable to complete the tomb of Julius II, he fulfilled his contract by painting the ceiling of the Sistine Chapel. There his love of drawing came to its

RAPHAEL SANZIO. *Pope Leo X.* **1518. Uffizi Gallery, Florence, Italy.** Raphael's ability as a portraitist is evident in his portrait of Pope Leo X, painted at the end of the artist's life. The composition focuses attention on

the figure of the pope, who sits at a table as two attendants hover in the background. The arrangement of the figures and the various shades of red help to unify the painting, despite the gazes of the figures, which lead in different directions out of the work. The objects on the table and the fabrics of the garments are depicted with such lifelike detail that one feels they could almost be touched.

63

MICHELANGELO BUONARROTI. Ceiling of the Sistine Chapel. 1508-12. The Vatican.
In this fresco, Michelangelo concentrated on the main elements of the story of the creation, fall, and expulsion of Adam and Eve from the Garden of Eden. The Sistine ceiling is an explanation of salvation according to the teachings of the Roman Catholic church. The Protestant Reformation of the 15th century had forced the church to confront the questions of sin, grace, and salvation. Michelangelo painted a complex symbolic programme in which figures from the Old Testament foretell the coming of Christ and his redemption of people from the bondage of Adam's and Eve's sin.

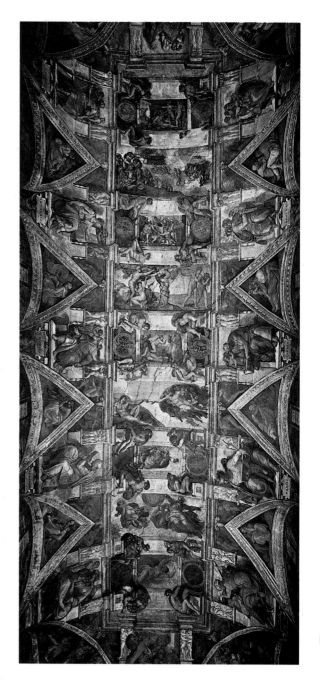

fullest expression. While the work is unified by the painted architecture and the relationships between the figures, the emphasis is on the individual figures. The figures appear to be sculpted out of stone. The ceiling completed a programme that had been started 30 years earlier by the artists who had decorated the walls. Michelangelo's work depicts the history of people

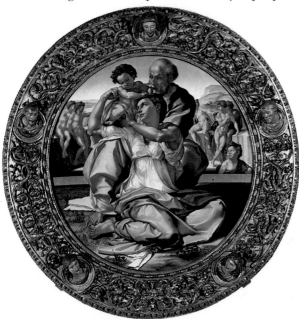

MICHELANGELO BUONARROTI. *The Holy Family* **or the Doni Tondo. 1506. Uffizi Gallery, Florence, Italy.**
This panel was commissioned for the marriage of Agnolo Doni and Magdalena Strozzi. The composition of the group in the foreground breaks away from the triangular format that was first used by Leonardo and then by Raphael. The turning and twisting of Mary as she reaches behind her to grasp the Christ child is a unique and radical foreshortening of the human figure. Mary, Joseph, and Jesus fill most of the space. Michelangelo has drawn them as if they were sculptures. They are completely interrelated through their gestures and poses, as if carved out of a single block of stone. The small figures in the background are not related to the central group or theme, but appear to have provided an opportunity for Michelangelo to paint the human body.

since their creation, the fall from grace, and the expulsion from the Garden of Eden. The frescoes on the walls tell of life under the laws of the ten commandments and the redemption of people under Christ.

Michelangelo also painted the wall behind the altar of the Sistine Chapel. *The Last Judgment* combines the Christian themes of the resurrection of Christ and the last judgment. In this work, Christ appears as a mythological god. Michelangelo completes the reconciliation of antiquity, humanism, and Christianity. He executes a vigorous composition in which the figures

GIORGIONE GIORGIO DEL CASTELFRANCO. *The Three Philosophers.* **1505. Kunsthistorisches Museum, Vienna, Austria.**

Giorgione moved Venetian art toward the High Renaissance. Like Leonardo, he balanced narrative with clear forms in a poetic landscape. In *The Three Philosophers*, the figures are in harmony with a luminous atmosphere that appears to be full of mystery. Form and theme are perfectly combined into a work of poetic imagination.

JEAN FOUQUET. *The Virgin and Child with Angels.* **1450. Royal Museum, Antwerp, Belgium.**

The figure of the Virgin in *The Virgin and Child with Angels* was modelled on Agnes Sorel, mistress of the king of France. This strange superimposition of themes and characters was only understood by a handful of people connected to the royal court. Fouquet depicts the figures in simplified, geometric fashion, as if they were composed of spheres, cones, and cylinders. They appear to be sculpted out of marble because of the glossy shine on their skin.

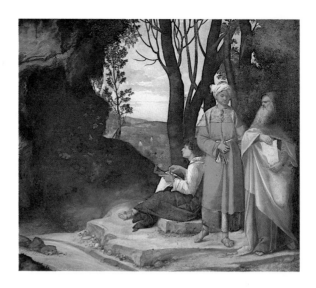

of the blessed and the damned whirl about the central figure of Christ, creating a dramatic feeling.

While many of the developments of the High Renaissance took place in Rome, Venice was also a centre of artistic activity in the late 15th and

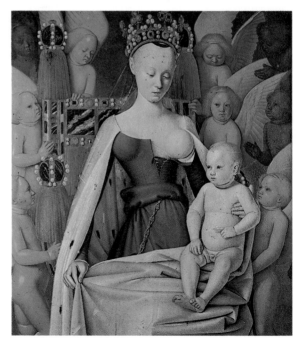

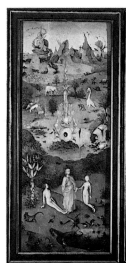
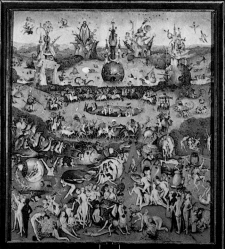
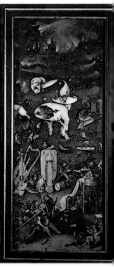

early 16th centuries. The painter Giorgione mixed the artistic heritage of the Bellini brothers with contributions of Leonardo to form a new concept. In Giorgione's work, the qualities of colour, sfumato, and light, which were used to capture reality in a painting, were applied to rural and mythological scenes and gave them poetical and pictorial unity.

The pictorial language of the Italian Renaissance sparked the interest of artists elsewhere. They studied the work of the Italian artists by travelling to Italy to see it firsthand or by obtaining prints and engravings.

In northern Europe, before the ideas of the Italian Renaissance were known, artists had already developed an advanced style of painting that rivalled that of Italian artists. The northern artists painted the natural world, used a system of perspective, painted objects realistically, and captured people's expressions in portraiture.

The first artists of the northern or Flemish Renaissance were the brothers Jan and Hubert van Eyck, who painted the Ghent Altarpiece in 1432. Robert Campin and Roger van der Weyden

HIERONYMOUS BOSCH. *The Garden of Earthly Delights.* **1510. Prado Museum, Madrid, Spain.** Bosch's genius lies in his ability to translate his ideas about religion and morality into vivid, often cryptic imagery. A fantastic, imaginary landscape contains nude figures, animals, and horrible monsters. The central panel of his triptych of *The Garden of Earthly Delights* presents a wide variety of the pleasures in life. The side panels represent heaven on the left and hell on the right.

ALBRECHT DÜRER.
Adam and Eve. **1507.**
Prado Museum, Madrid, Spain.
In Dürer, theorist, graphic artist, and painter come together. Theory was of great importance to Dürer because it explained all the greatness of ancient art. In this version of Adam and Eve, Dürer seeks to show models that are perfectly proportioned. Dürer used nine heads to the length of the body, instead of the eight heads he used in earlier engravings. This change was the result of Dürer's studies in Venice. In his drawings of the figures of Adam and Eve, the soft outlines and delicately drawn anatomy are combined with slightly affected gestures and a feeling of imbalance, an influence of earlier Gothic art.

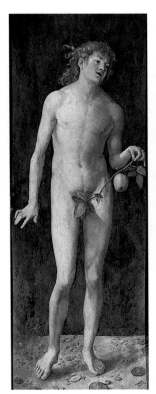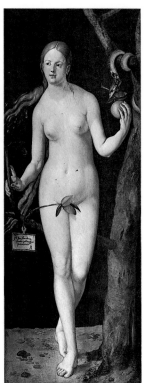

are noted for their delicately coloured and luminous works that are rich in descriptive detail.

Hugo van der Goes's *Portinari Altarpiece* brought to Renaissance painting the Flemish vision of landscape. The work has a great concern for detail and lighting that is like Leonardo's sfumato —with imperceptible shifts of tone from light to dark.

The strange personality of Hieronymous Bosch stands out among Flemish and Dutch painters. Bosch painted obsessive allegories of sin, good, and evil—medieval themes—but used the images and compositional methods of the northern Renaissance, as in *The Garden of Earthly Delights*.

The Flemish tradition was continued by 15th-century painters in France, but with particular emphasis on portraiture. Jean Fouquet was

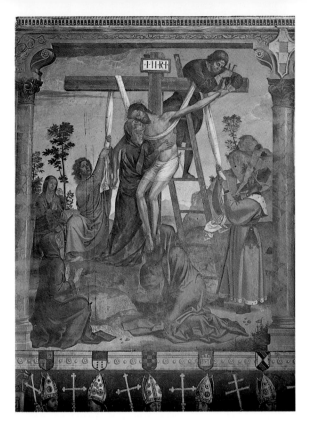

JUAN DE BORGOÑA.
The Descent from the Cross. **1512. Chapter House, Toledo Cathedral, Toledo, Spain.**
Juan de Borgoña, who trained under Ghirlandaio in Florence, created a school of artists in Toledo. Here he displays his taste for and mastery of quattrocento art. The scenes of the work are separated from one another by columns painted in the frescoes, yet they remain unified because the background landscape seems to continue behind the columns. Below the scenes from the New Testament are portraits of the bishops of Toledo.

influenced by both the Flemish and the Italian artists. In the 16th century, Italian artists came to work for the French kings and had a great influence on French painting.

The German artist Albrecht Dürer travelled to Flanders, Holland, and Italy. In Italy he saw the work of Giovanni Bellini and Leonardo, which stimulated his interest in proportions, harmony, and light, as shown in *Adam and Eve* (1507). Humanistic concerns were of particular interest to Dürer, and he wrote theoretical treatises on proportion and perspective.

In Spain, there were many artistic centres in the 15th century. Artists were influenced by Gothic art and also had a close connection to Flemish painting, which led to the development of the Hispano-Flemish style. The earliest examples of

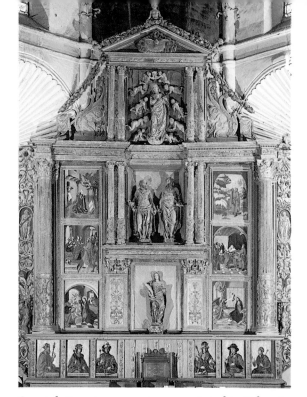

**PEDRO BERRUGUETE.
Altarpiece of the Conception of the Virgin Mary.
1485. Church of Santa
Eulalia. Paredes de Nava,
Spain.**
*The Count of Montefeltro
and his Son.* **1476. Ducal
Palace of Urbino, Urbino,
Italy.**
Berruguete worked in the court of Urbino. While there, he painted this portrait of the count of Montefeltro with his son (above). When he returned to Spain, he concentrated on large works that contained both real architectural elements as well as painting. In the altarpiece in Paredes de Nava (right), the figures appear to be real. The use of a flat gold background behind the figures was common in medieval painting.

Spanish Renaissance art were painted in Valencia, a Mediterranean city closely linked to Italy. Many of the artists in the city went to Italy and then returned and painted works that reflect the influence of the Italian Renaissance. In Toledo, the artist Juan de Borgoña, who had trained in Italy, painted the Chapter House frescoes for the Toledo Cathedral. His influence on the artists he trained was great. The most important figure of the Spanish Renaissance was the Castilian artist, Pedro Berruguete, who was trained in Flanders and worked in the Italian city of Urbino. He adopted a new language in the layout of architectural settings. His treatment of light and shadow closely resembles that found in the work of Italian painters.

DESIGN AND THE GRAPHIC ARTS

FRANCESCO DA COLONNA. Engraving. *Hypnerotomachia Polyphili.* **1499. Venice, Italy.**

During the Renaissance, engraving was an important means of making multiple copies. It was a new process that allowed for the printing and distribution of designs, forms, and themes. One of the most beautiful books that contained engraved illustrations was the *Polyphili.* This novel described architecture, monuments, fountains, sculptures, paintings, and designs. Some of these were illustrated by an anonymous master. The text, written in a mixture of Latin, Greek, and Italian, was understandable only to the very well educated. The illustrations were an important source for artists.

Drawing became very important during the Renaissance. Drawings were usually studies from the natural world (humans, plants, animals, and landscapes). They served as the sketches for new artistic creations or as illustrations for theories on composition, urban planning, and perspective.

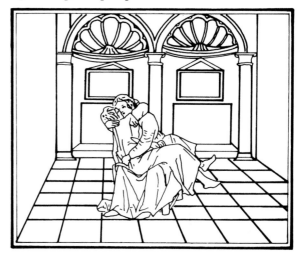

PATIENTIA EST ORNAMENTVM CVSTODIA ET PROTECTIO VITAE.

Engravings and woodcuts allowed a greater number of people than ever before to enjoy artistic images. They were the earliest mass-reproduced images. The next artistic form to have such an impact was photography, invented in the 19th century.

The most important engravers were the Pollaiuolo brothers in Italy and the Germans Martin Schongauer and his pupil Albrecht Dürer. During the 16th century, engravings were used primarily as prints, that is, as reproductions of the pictures and decorative designs of various artists. Woodcuts were used most frequently as book illustrations. Prints and illustrated books were distributed throughout Europe and helped spread the visual ideas of the Renaissance.

ALBRECHT DÜRER. Engraving from *The Apocalypse*. 1498. Engravings and their use as book illustrations allowed a larger number of people than ever before to see artistic images. A shift from wood blocks to metallic plates allowed a greater degree of detail, as shown in this engraving by Dürer, one of the greatest masters of the graphic arts. The precision of the lines, the contrast of light and dark, and the ornamental inventiveness of the lettering all show Dürer's skill. Dürer's work helped make the illustrated book into an important source of visual ideas for artists.

THE DECORATIVE ARTS

Renaissance artists worked with furniture, ceramics, glass, gold, silver, wrought iron, clothing, and even hairstyles and gardens. All the decorative art objects produced during the Renaissance had one element in common with architecture, sculpture, and painting: ornamentation. Initially, motifs were taken from nature. Ghiberti decorated the baptistry doors of the cathedral in Florence with garlands, flowers, leaves, fruits, birds, and reptiles. Other artists, such as the della Robbia brothers in their ceramics, Verrochio in the Medici Tombs, and the Bellini brothers in their paintings, developed decorations taken from nature. Artists also used decorations drawn from antiquity: sphinxes, centaurs, griffins, and harpies.

For wooden objects such as furniture, decorated ceilings, and church pulpits artists used three basic techniques: carving, painted decoration, and inlay work, or **marquetry**. Carving required no special preparation of the surface, but if the wood was to be painted, the surface was prepared with a thin layer of gesso or paste. Marquetry was considered the best way to decorate wood. Wood, stones, and shells of various colours were used to create landscapes or romantic, imaginary scenes.

Artists also executed beautiful wrought-iron ceilings, lampstands, and balconies, did embossed steelwork—especially arms, armour, and helmets—

LENDINARA. Marquetry. c. 1470. Ducal Palace of Urbino, Urbino, Italy. Marquetry was used to create lifelike scenes, just as painting was, and followed the same rules of perspective to simulate three-dimensional reality. Artists used wood, stones, or shells to create the scenes.

and worked in cast metal. Gold and silver work reached new artistic heights during the Renaissance, and many artists produced elegant works for homes, churches, and monasteries.

The quality of ceramics was also high during the Renaissance, especially in centres such as Faenza in Italy. There was produced a variety of pottery known as *majolica*, because of its origin in Majorca. Two important centres for the production of ceramics existed in Spain. In Seville, the Italian artist Nichola Pisano introduced fanciful ceramic decoration in the entrance to the Church of Santa Paula (1504). The second centre was Talavera de la Reina.

The most famous centre for glass was Murano, near Venice. A special type of glass was made there, which was highly valued throughout Europe. In these pieces, strands of brightly-coloured glass

were embedded in a coating of clear glass and appear to float. Stained-glass windows continued to be manufactured during the 16th century, especially in Spain. Beautiful examples are preserved in the cathedrals of Seville and Granada.

Textiles of silk, wool, and linen often were used with gold or silver thread to create rich and sumptuous vestments and hangings for churches. Antonio Pollaiuolo drew scenes from the life of John the Baptist for the silk decorations in the baptistry of the Florence Cathedral. Tapestries, executed primarily in Flemish workshops, were sometimes based on drawings done by great artists, such as Raphael.

INDEX OF ILLUSTRATIONS

ÁLAVA, Juan de: Salamanca University. 25

ALBERTI, Leone Battista: Church of Santa
Maria Novella. 22
Facade of the church of San Francisco. 23
Palazzo Rucellai. 29

AMADEO, Giovanni Antonio: The
Charterhouse. 23

BELLINI, Giovanni: *Inconstant Fortune.* 11

BERRUGUETE, Pedro: Altarpiece of the
Conception of the Virgin Mary. 70
The Count of Montefeltro and his Son. 70

BORGOÑA, Juan de: *The Descent from
the Cross.* 69

BOSCH, Hieronymous: *The Garden of Earthly
Delights.* 67

BOTTICELLI, Sandro: *Judith.* 53
The Discovery of the Body of Holofernes. 52

BRAMANTE, Donato: Church of
Santa Maria presso San Satiro. 8
Tempietto de San Pietro in Montorio. 21
Cloister of Santa Maria della Pace. 27

BRUNELLESCHI, Filippo: Florence
Cathedral. 16
Ground plans. Churches of San Lorenzo and
San Spirito. 17
Church of San Lorenzo. 18
The Old Sacristy. Church of San Lorenzo. 19
Ground plan. Pazzi Chapel. 20
Ground plan. Church of Santa Maria degli
Angeli. 30

BUONARROTI, Michelangelo: Dome of
Saint Peter's. 20
The Battle of the Centaurs. 41
David. 42
The Medici Tombs. 43
Dying Slave. 44
Rondanini Pietà. 45
Ceiling of the Sistine Chapel. 64
The Holy Family or the *Doni Tondo.* 65

CARPACCIO, Vittore: *The Miracle of the
Reliquaries of the Holy Cross.* 60

CASTAGNO, Andrea del: *The Last Supper.* 52

CIONI, Andrea di Michele: see **Verrochio.**

COLONNA, Francesco da: *Hypnerotomachia
Polyphili.* 71

DA VINCI, Leonardo: see **Leonardo.**

DEL CASTELFRANCO, Giorgio: see **Giorgione.**

DELLA FRANCESCA, Piero: see **Piero.**

DI BETTO, Bernardo: see **Pintoricchio.**

DONATELLO:
The Prophet Habakkuk. 33
Saint George. pedestal relief. 35

DÜRER, Albrecht: *Adam and Eve.* 68
Engraving from *The Apocalypse.* 72

FORMENT, Damián: High Altar. 47

FOUQUET, Jean: *The Virgin and Child
with Angels.* 66

GHIBERTI, Lorenzo: Baptistry doors.
Florence Cathedral. 34

GHIRLANDAIO, Domenico: *The Visitation
of Mary.* 56

GIORGIONE: *The Three Philosophers.* 66

IBARRA, Pedro de: Courtyard of the Fonseca
Palace. 27

LAURANA, Luciano: Entranceway to the
castle of Alphonso V, the Magnificent. 31

LENDINARA: Marquetry. 74-75

LEONARDO DA VINCI: *The Adoration of
the Magi.* 61

LIPPI, Filippo: *Coronation of the Virgin.* 50

LOMBARDO, Pietro: Church of Santa Maria
dei Miracoli. 24

MANTEGNA, Andrea: The San Zeno
Altarpiece. 57
The Agony in the Garden. 58
Ceiling of the Camera degli Sposi. 59

MARTINI, Francesco di Giorgio: Column.
capital. and basilica ground plan. 6
The Ideal City. 15

MASACCIO, Tomasso di Giovanni:
The Trinity. 10
Saint Peter Helping the Sick with His Shadow. 49

MICHELOZZI, Michelozzo: Cloister of
San Marco. 27
Palazzo Medici-Riccardi. 28

MORLANES, Gil: Facade of the church of
Santa Engracia. 25

ORDÓÑEZ, Bartolomé: *The Martyrdom of
Saint Eulalia.* 46

PERUGINO, IL: *Christ Delivering the Keys to
Saint Peter.* 9

PIERO DELLA FRANCESCA: *The Duke
of Urbino.* 13
The Victory of Heraclius over Chosroes from
The Legend of the True Cross. 54

PINTORICCHIO, IL: *The Life of Aeneas
Sylvius Piccolomini.* 55
The Borgia Pope. 54

POLLAIUOLO, Antonio: *Apollo and Daphne.* 5
Tomb of Innocent VIII. 40
Map of the Renaissance. 4
ROBBIA, Luca della: *Singing Gallery.* 36
ROSSELLINO, Bernardo and Antonio:
Tomb of the cardinal prince of Portugal. 37
SAGREDO, Diego de: Proportions of the
human body. *Roman Measurements.* 6
SANZIO, Raphael: *The Disputation
Concerning the Blessed Sacrament.* 62
Pope Leo X 63
SETTIGNANO, Desiderio da: Tomb of Carlo
Marsuppini. 39
SILOÉ, Diego de: Granada Cathedral. 22
The Gilded Staircase. 48
UCCELLO, Paolo: *The Battle of San Romano.* 51
VALLEJO, Juan De: Arch of Santa Maria. 26
VANNUCCI, Pietro: see **Perugino**.
VERROCHIO, Andrea del: *Colleone.* 38
VITRUVIUS: Orders of architecture and
of capitals. *De Architectura.* 7

ART THROUGHOUT THE AGES

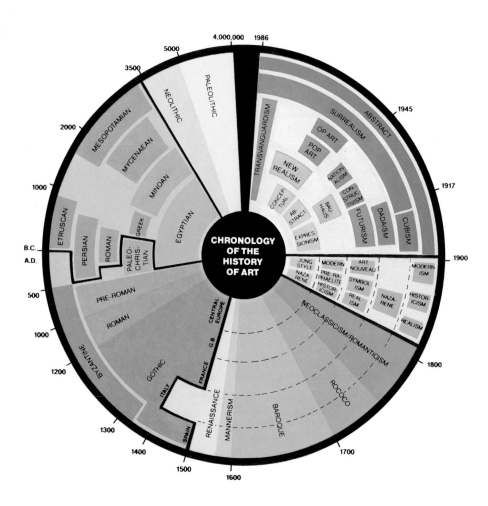

This chart shows the evolution of Western and Near Eastern art through the ages. The terms are those that art historians traditionally use to label periods of time in various cultures where definite stylistic tendencies have occurred. The books in the Key to Art series examine the interplay of artists, ideas, methods, and cultural influences that have affected the evolution of specific art styles.

GLOSSARY

antiquity The culture of ancient Greece and Rome

apse A semicircular niche, usually placed at the east end of a Christian church

arch A curved structure used to span an opening such as a window or door

architrave The lowest portion of the entablature that rests on architectural columns

baptistry A part of a church used for baptism

basilica A longitudinal church having a nave, apse, side aisles, and side chapels

capital The uppermost piece of a column or pillar

choir A rectangular area in a church that is usually marked off by steps, a railing, or a screen

cloister An open court attached to a church or monastery that is surrounded by a covered walkway

column A cylindrical, upright architectural support

cupola A rounded vault forming a roof or ceiling

entablature The horizontal structure that rests on columns in classical architecture

facade The principal face or front of a building

fresco Painting on freshly spread plaster

frieze The middle portion of an entablature, often decorated with a horizontal band of relief sculpture

humanism Renaissance doctrine based on secular concerns, the revival of classical culture, and humanity as the centre of all things

marquetry Decorative work in which elaborate patterns are formed by the insertion of pieces of wood, shell, or ivory into a wood veneer

palazzo A large, official building or a private town house

pediment A round or triangular piece used over a door or window

pendentive A curved support shaped like a triangle. Pendentives hold up a dome.

pier An upright architectural support

pilaster An upright rectangular column that usually projects a third of its width or less from a wall

plateresque Characterized by the 16th-century Spanish architectural style of elaborate ornamentation suggestive of silver plate

retable A decorated wall behind an altar

retro-choir The area behind the altar or choir in a church

rusticated Uncovered, with joints conspicuous

sacristy A room in a church where sacred vessels and vestments are kept

sfumato Delicate gradations of light and shade in the modelling of figures

transept A cross arm in a basilican church

triptych A painted or carved picture with one central panel and two hinged wings

vault An arched roof or ceiling

volute A spiral ornament on a capital

CONTENTS

INTRODUCTION . 3
ARCHITECTURE 15
SCULPTURE . 33
PAINTING . 49
DESIGN AND THE GRAPHIC ARTS 71
THE DECORATIVE ARTS 73
INDEX OF ILLUSTRATIONS 76
ART THROUGHOUT THE AGES 78
GLOSSARY . 79

FURTHER READING

CENNINI, C. D. *The Craftsman's Handbook*. Dover Publications.
MURRAY, P. *Renaissance Architecture*. Faber.
PANOFSKY, E. *The Renaissance in Western Art*. Harper & Row.
PANOFSKY, E *Studies in Iconology; Humanistic Theories in the Art of the Renaissance*. Harper & Row.
VASARI, G. *The Lives of the Painters, Sculptors & Architects*. *Volumes 1-4*. Dent.
WITTKOWER, R. *Architectural Principles in the Age of Humanism*. Academy Editions.

ACKNOWLEDGEMENTS

A.P.: pp. 54, 70; I.G.D.A., Milan: pp. 3, 5, 8, 9, 11, 13, 15, 16, 18, 20, 21, 23, 24, 27, 29, 31, 33, 34, 35, 36, 37, 38, 39, 40, 41, 43, 44, 45, 49, 50, 51, 52, 53, 54, 55, 57, 58, 59, 60, 61, 62, 64, 65, 66, 74, 75; Oronoz, Madrid: pp. 22, 25, 26, 27, 46, 48, 67, 68, 69, 70; Scala, Florence: p. 56.